# 🐾 Fluffy Humpy Poopy Puppy

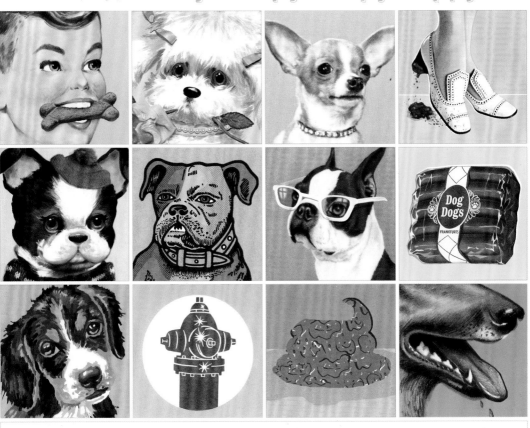

## A Ruff, Dog-Eared Look at Man's Best Friend

Charles S. Anderson Design Company
Text by Michael J. Nelson

Abrams Image
New York

www.popink.com
www.csadesign.com
www.csaimages.com

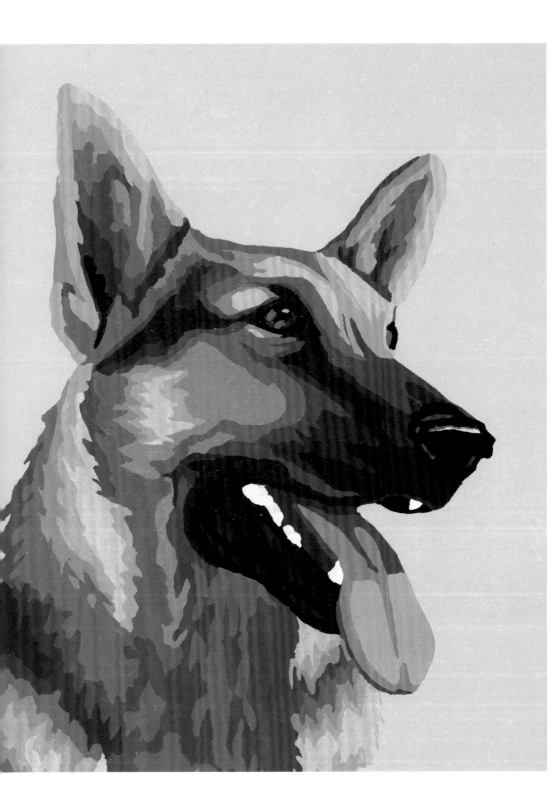

*Pop ink*

# Fluffy Humpy Poopy Puppy

A Ruff, Dog-Eared Look at Man's Best Friend

Perhaps no creature's fate has ever been more intertwined with ours than the dog's. Certainly some may protest, saying, "Ah, but what about the louse?" True, head lice have enjoyed a privileged place in our history, too, clinging as they do to our hair, occasionally slipping off to sip blood from our scalps before birthing a load of their hideous spawn, who then glue themselves to other hairs before hatching—they in turn helping themselves, uninvited, to more meals of our blood. But it's hard to imagine any right-thinking person putting out a beautiful, full-color book featuring charming pictures of our friends the head lice.

No, it is the dog that is man's best friend. Dogs never lay eggs in our hair and rarely suck blood meals from our scalps. And that is why we love them.

No one knows for sure when man and dog first forged their warm friendship, but that doesn't stop people from theorizing madly about how it might have happened. One theory holds that the ancient ancestors of dogs approached the fires of our ancient ancestors, who fed them bits of food–pan-roasted mammoth and whatnot–until they earned the animals' trust. Like most untestable theories, this one is, more than likely, a giant load of crap. The more probable theory is that dogs are actually descendants of some prehistoric race of hairy men who lost a bet, agreed never to speak again, and promised not to develop tools. With no axes or flint spears in their arsenal, they were forced to mooch food off their armed cousins and, after a few thousand years, they devolved, grew tails, and began their long and heated rivalry with the squirrel.

The first appearance of the dog is in Ancient Egypt. Hieroglyphs depict dogs racing, hunting, chewing up the pharaoh's favorite snake-themed headdress, and whizzing on his flax throw rug. So revered were dogs, that upon death, they were often gutted, de-brained, and stuffed with natron salts until desiccated. Then they were lovingly wrapped in cloths and set in tombs next to their masters to rot for the next thousand or so years.

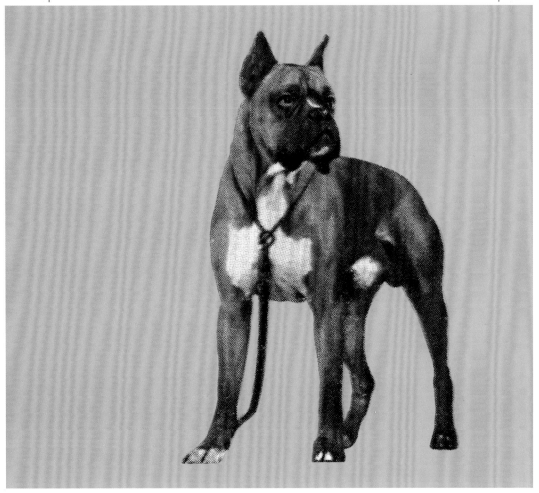

The Egyptian god Anubis, whose job it was to guide the dead through the afterworld (so that they didn't stumble into a lake of fire or stub their toes on sleeping devils), offers further proof of the extent to which the Egyptians honored the dog. Anubis had the body of a man and the head of a dog, an anatomical quirk that had to be frustrating–imagine having the mentality of a canine but the inflexibility necessary to lick your own genitalia.

In Europe, too, dogs have a long history. The Greek historian Strabo notes that as early as 63 BC, hunting dogs were being exported from Britain, the British finding no further need for them (having discovered a tempestuous love of pudding).

And of course the dog has also enjoyed a privileged place in American history as well. George Washington himself had many dogs, some of his favorites being Mopsey, Taster, Tipler, Forester, Lady Rover, Vulcan, Searcher, and Sweetlips. His historic return to Mount Vernon, shortly after the Battle of Monmouth, when the great man called out to his beloved dogs, "Here Mopsey! Come my widdle Sweetlips! Come to Papa Georgie!" remains one of the most babyish moments in American history.

*Fluffy Humpy Poopy Puppy* is a loving tribute to man's oldest and smelliest friends. We hope that you will smile in warm recognition at the beautiful full-color renderings of terriers, shepherds, pointers, dalmatians—and mutts, too—doing what they do best: frolicking, hunting, fetching, chewing, humping, and pooping. Yes, lots of pooping.

So settle down with your favorite pet and enjoy *Fluffy Humpy Poopy Puppy* (though we suggest you keep the book out of reach or the stupid mutt will chew the damn thing to shreds).

# CHEESE DOGS

What a puss. What kind of self-respecting dog allows himself to be dressed up in ribbons and bows? A few days of being dolled up like this and it's, "Oh, you guys go ahead and harass the red squirrels without me. I gotta get a blow-out and straightening this afternoon, and I don't want to soil my coat." Or, "I would like to help you drag down that injured deer, but my ear bows might get caught in the underbrush." Dogs, here's a little piece of advice: Start going down this road—playing dress up, floofing out your hair, getting all big-eyed and cute—and you may as well be a cat.

This dog has clearly gone over the cliff. He looks like a panda bear, for crying out loud. Look, lose the ribbon, drop the pansy (or whatever the hell it is), pick up a bloody rabbit carcass, and we'll talk. Until then, have a great time eating your pooch paté out of a crystal goblet.

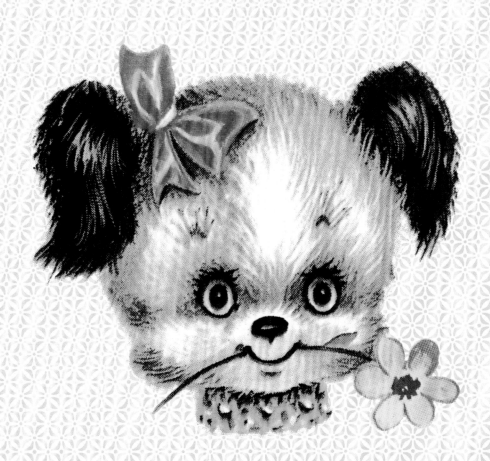

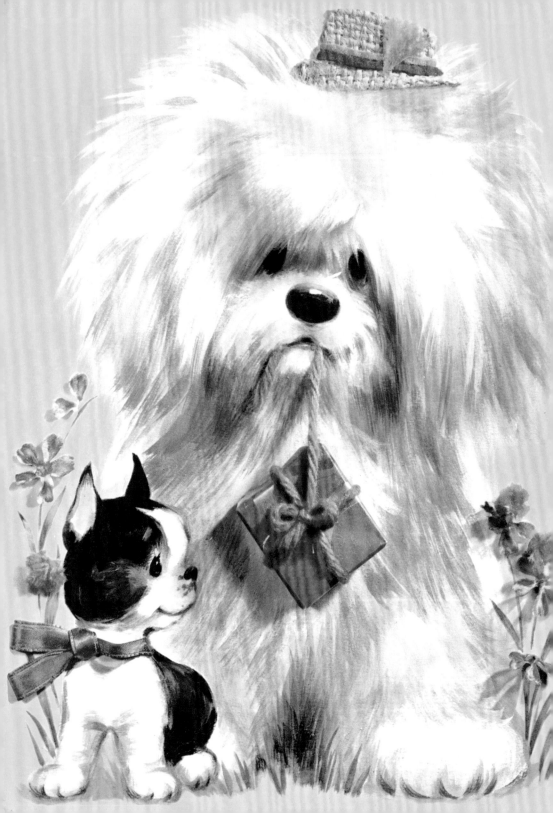

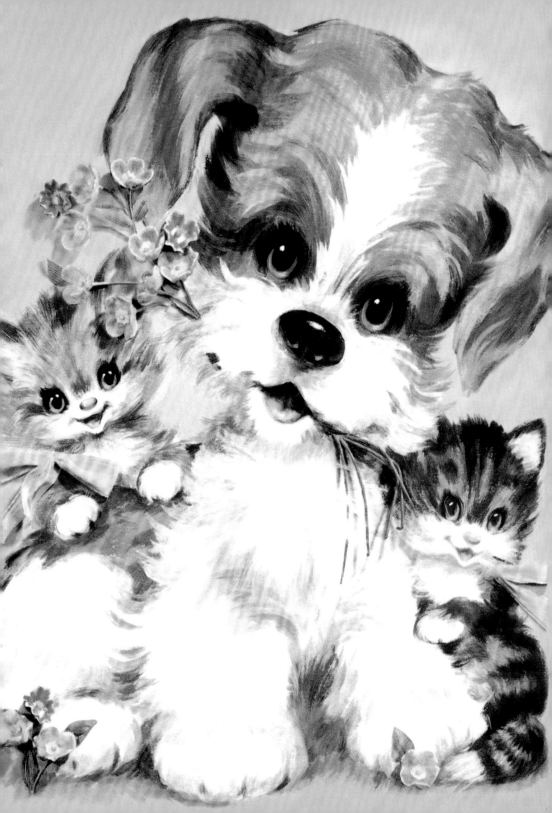

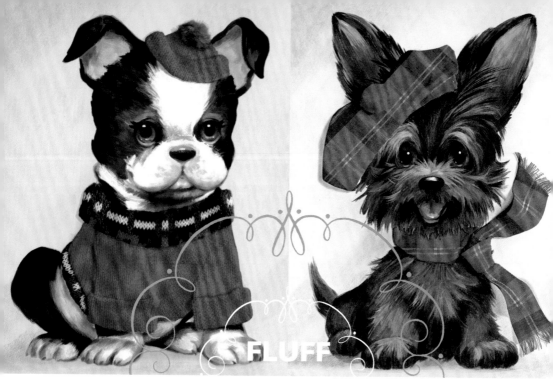

FLUFF

This is a perfect illustration of the saying, "It's like putting lipstick on a pig." All the knit caps and tartan scarves in the world won't cover up the fact that sooner or later, these little puffballs will have to circle the yard, assume the humiliating squat, and lay doggie cable like mad.

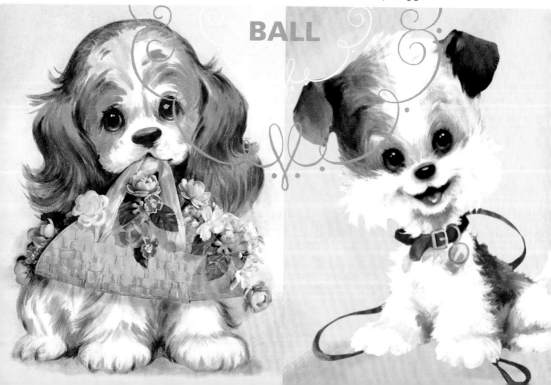

BALL

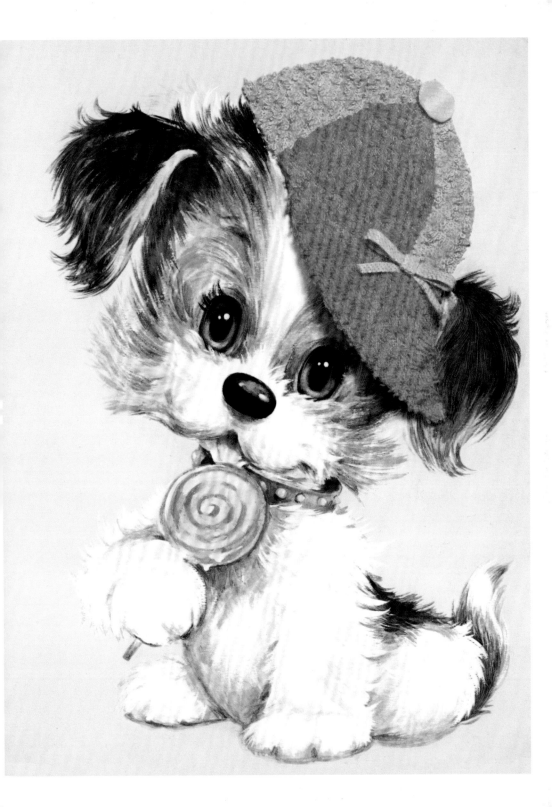

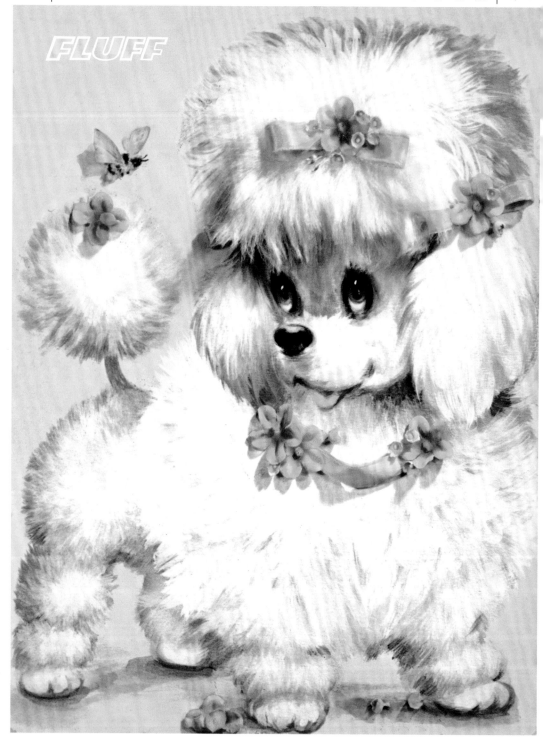

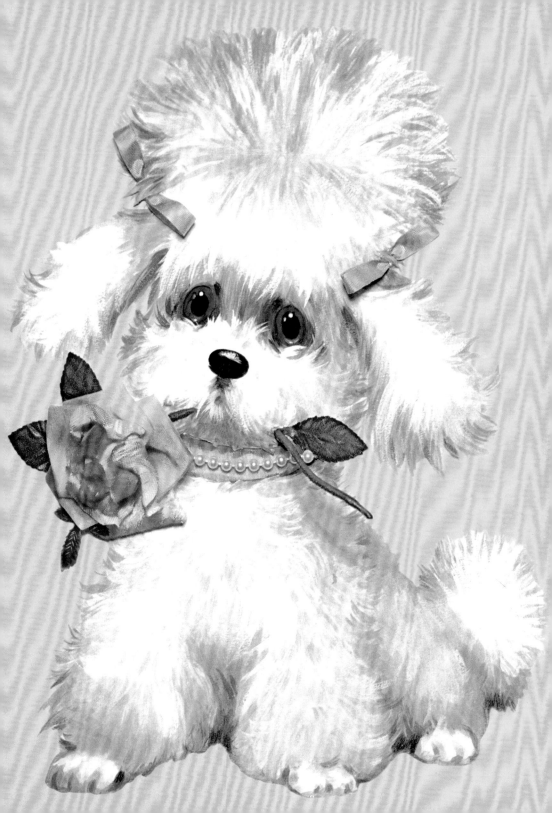

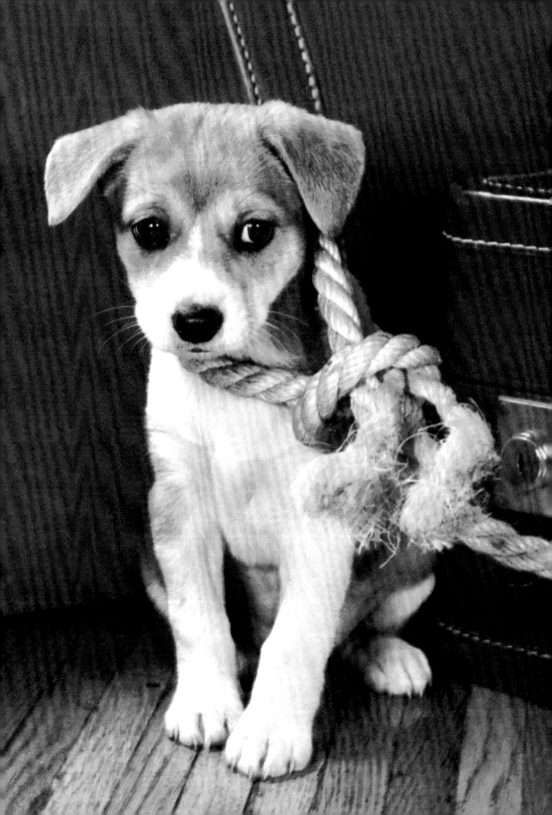

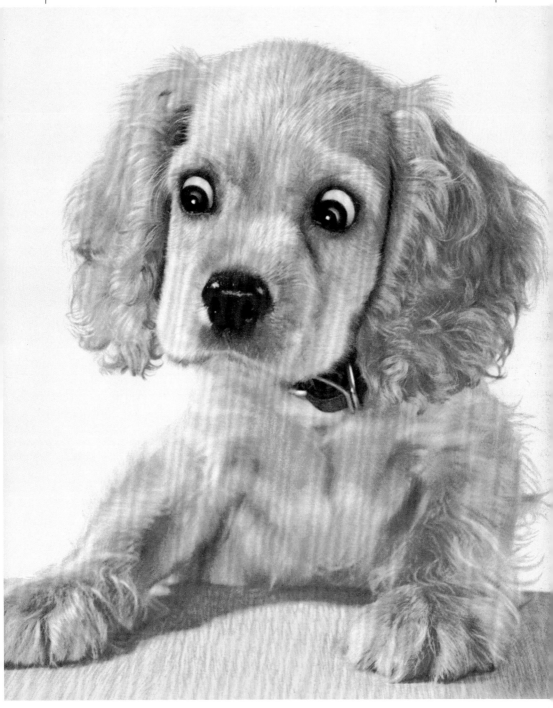

It just sank in: "You mean to tell me that you're going to put me under, incise the skin near my genitals, cut the spermatic cord, and remove my testicles? Why? What'd I do?!"

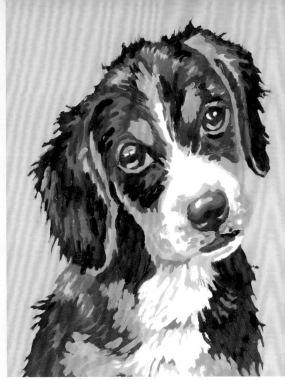

Any dog worth his dewclaws knows that in order to manipulate the human species, it is necessary to perfect the head tilt. For whatever reason, human beings find it irresistible when a dog manages to look even more clueless than usual.

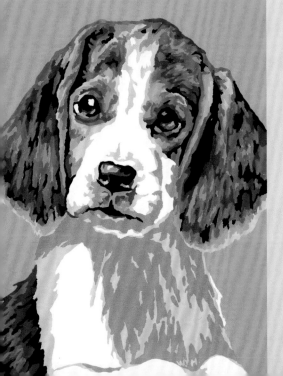
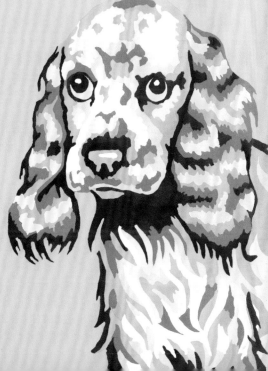

# A DOG & HIS BOY

Yes, a dog is a boy's best friend. And if that boy happens to be an odd-faced, little twerp with a weird, bell-shaped, striped shirt, then his best friend is bound to be a small, French dog wearing the stupidest-looking beret you've ever seen (and there are a lot of stupid-looking berets out there!) The boy on the opposite page has a best friend who is not so much a dog as an alien posing as a dog, waiting for the right time to soften up Earth for the upcoming invasion.

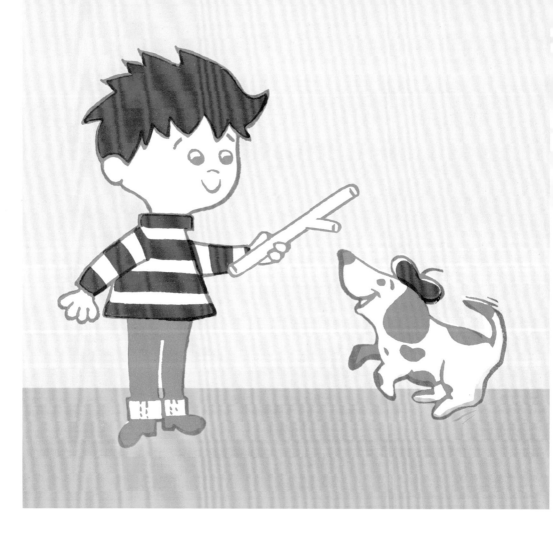

Fun

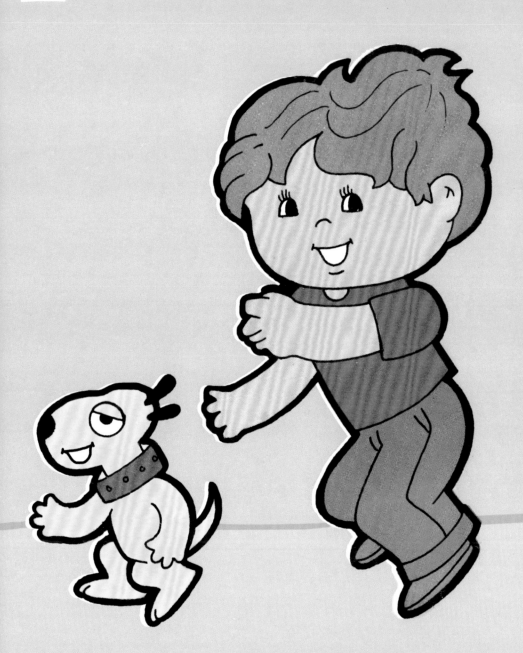

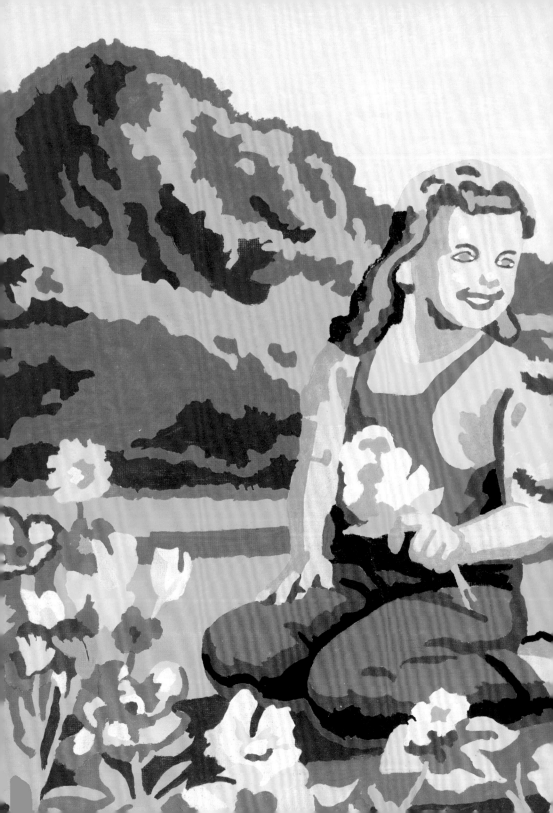

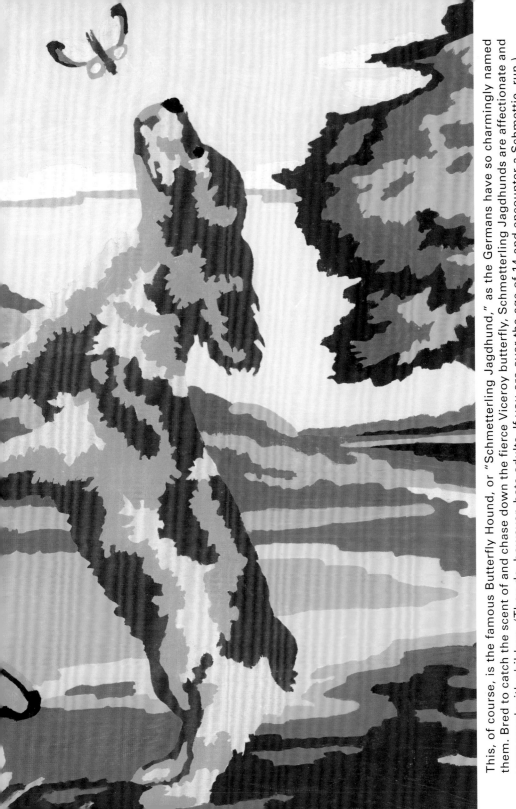

This, of course, is the famous Butterfly Hound, or "Schmetterling Jagdhund," as the Germans have so charmingly named them. Bred to catch the scent of and chase down the fierce Viceroy butterfly, Schmetterling Jagdhunds are affectionate and very good with children. (They do, however, hate adults. If you are over the age of 14 and encounter a Schmettie, run.)

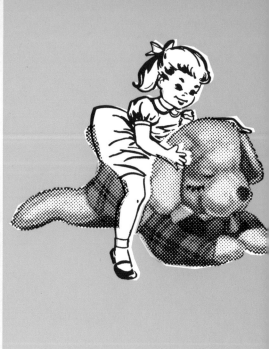

Girls, too, love dogs, whether just to wave at them, take them for walks in the brutal sun, hide things from them, blow bubbles near them, or dress them in plaid suits and jump up and down on their backs until they pass out.

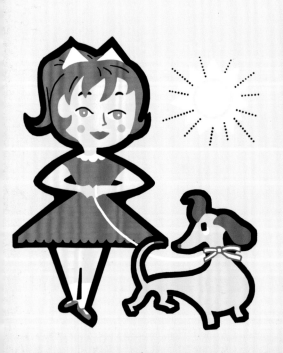

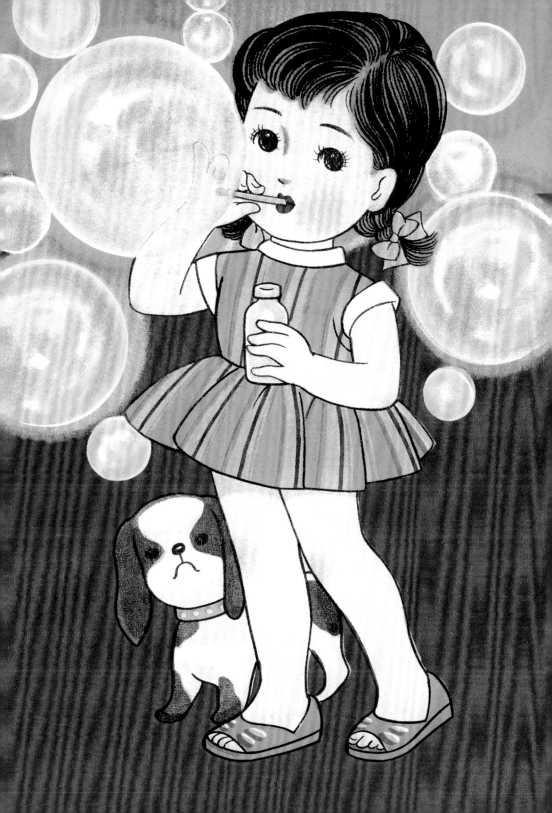

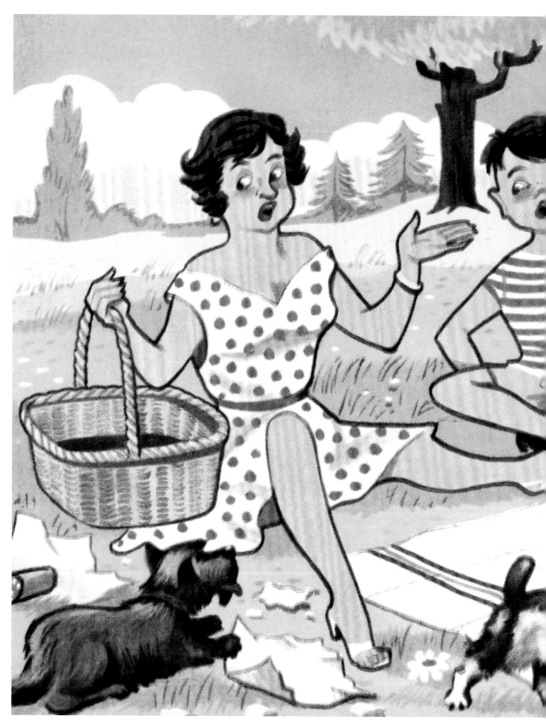

Oh, no! These little scamps are in danger of spoiling Truman Capote's picnic with his rented family. Not only is their meal in ruins, little Billy (not his real name) has a gnat in his eye,

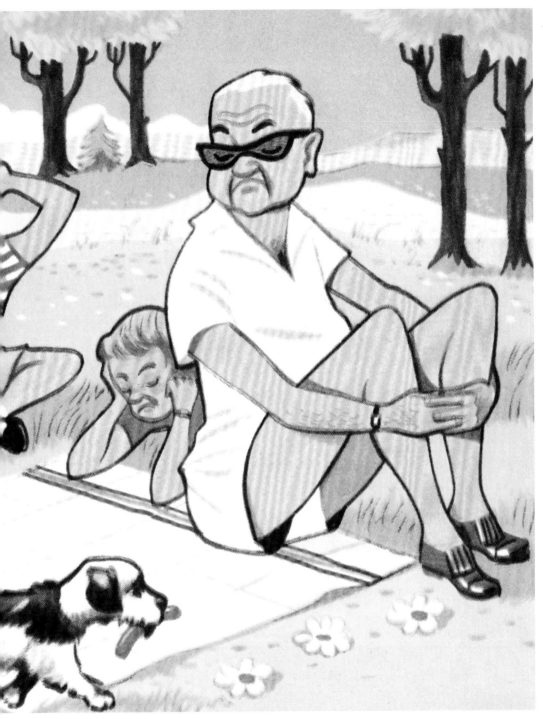

and one canine thief is getting his wiener dangerously close to Mr. Capote's kicky short-shorts. Suggestion: Return the family early and make a pitcher of cosmopolitans for yourself.

# DOGGIE STYLE

Beloved companions as they are, dogs are even more treasured for their luxurious fur. Whether it's used for smart dalmatian pillbox hats or warm and elegant St. Bernard collars, dog fur is the cat's meow. And it's currently de rigueur to heavily sedate one's poodle, and with the liberal use of cleverly placed bobby pins to attach it to one's head for use as an ultra-chic, ultrawarm hat that is at home with both evening or afternoon casual wear. Just make sure to carry extra sedatives with you lest your pooch rouse himself during the soup course, swan dive onto the table, and roll into your host's lap, whimpering softly and then urinating.

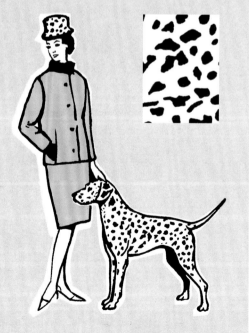

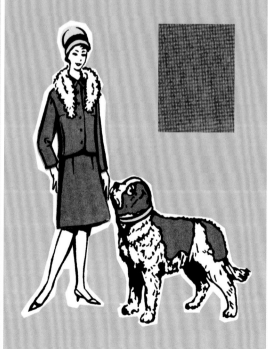

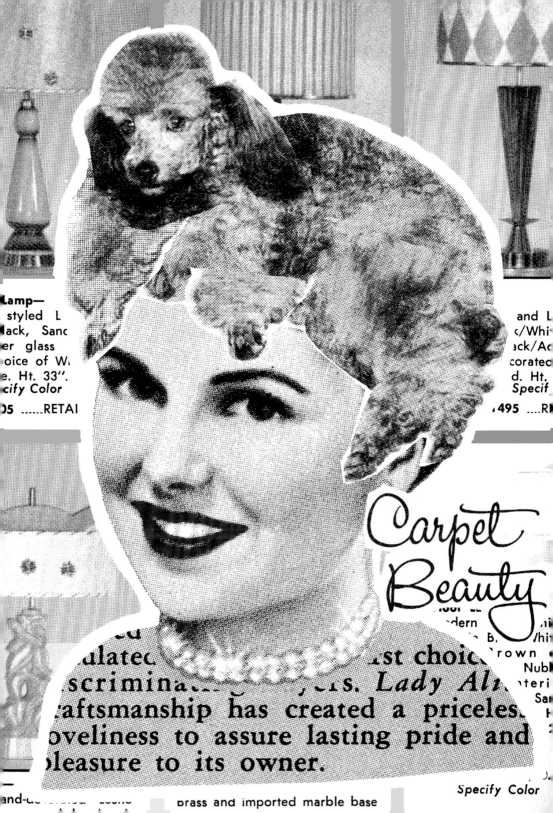

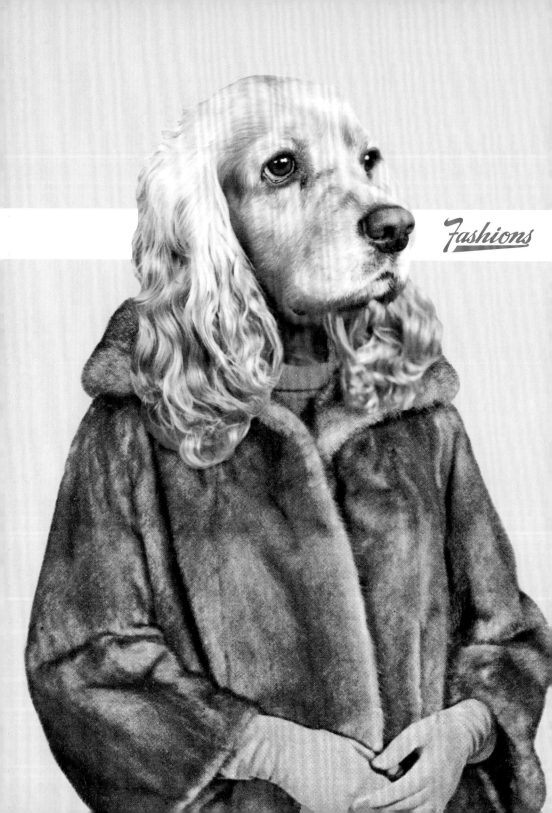

You don't like to go outside naked, so why make your pet suffer the humiliation of having their genitalia on display for all the customers at your local coffee shop to snicker at? Is it too much to ask that you bring him or her to the Men's Wearhouse or Talbots to sink a few grand on a little dignity?

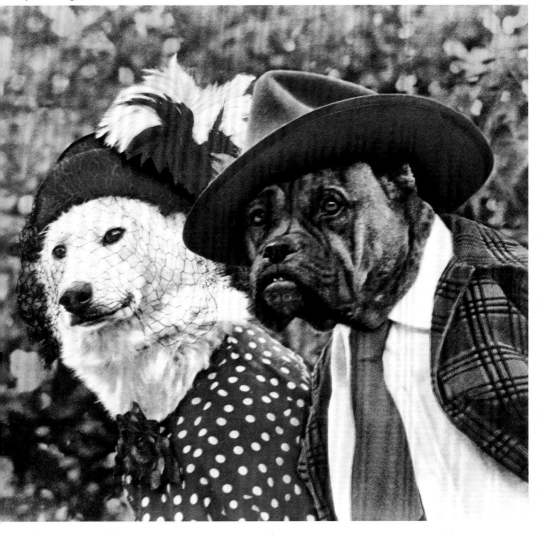

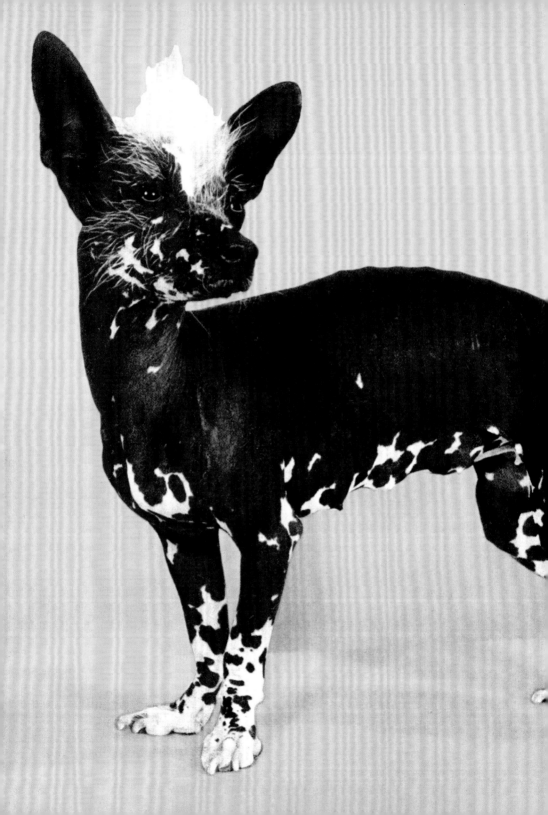

Let's face it, dogs have very little talent in the area of hygiene. Their fur too easily becomes filthy, tangled, and matted with dirt, oil, burrs, and deer ticks. You could do your dog's job and clean it, but why not take the easy way out and cut it all off, right down to the skin?

## FRENCH POODLE

The French have given us so much. Rich, vomit-scented cheeses, suicide-inducing existentialism, lung-clogging Gauloises cigarettes, mimes, whipped organ meats, Marshall Petain and the Vichy regime, some wines (I'm told), and of course the French poodle. The poodle is said to have originated from a breed of water spaniel, but recent research suggests that it is actually a cross between a Japanese snow monkey and a shrub. Because of its unusual breeding, the poodle, though lovely and obedient, is actually quite a bit dumber than a small clump of dirt. (Coincidentally, the same is true of the woman on the opposite page.)

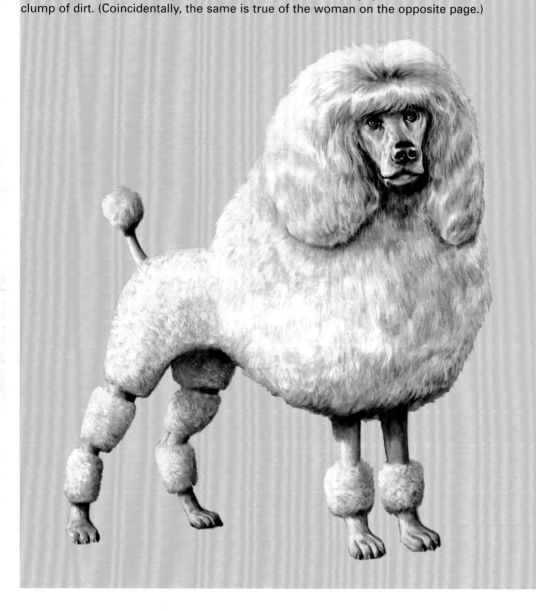

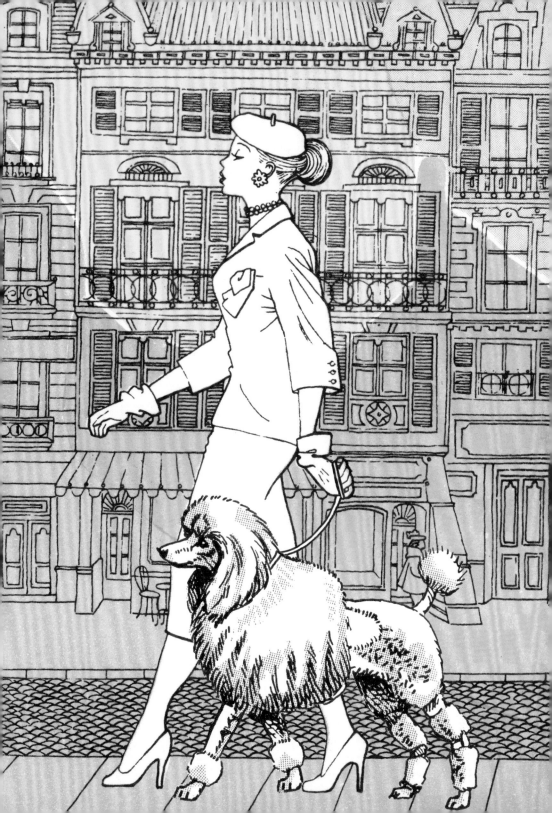

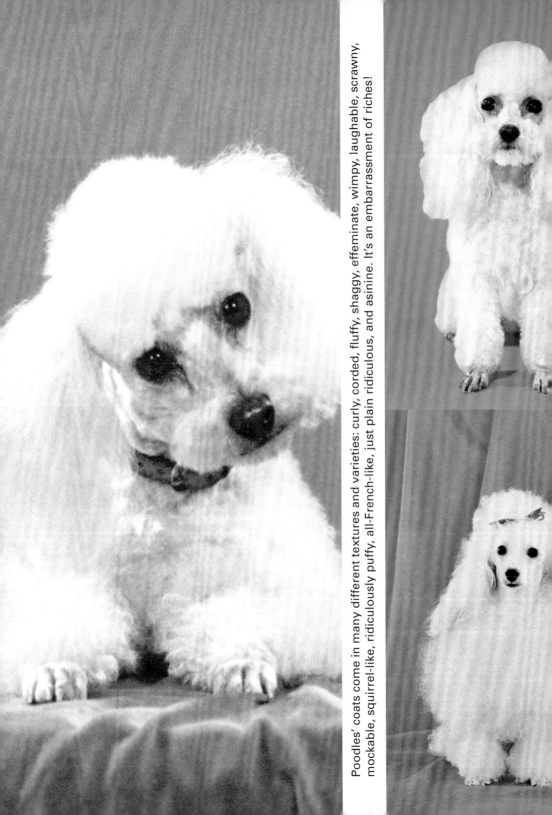

Poodles' coats come in many different textures and varieties: curly, corded, fluffy, shaggy, effeminate, wimpy, laughable, scrawny, mockable, squirrel-like, ridiculously puffy, all-French-like, just plain ridiculous, and asinine. It's an embarrassment of riches!

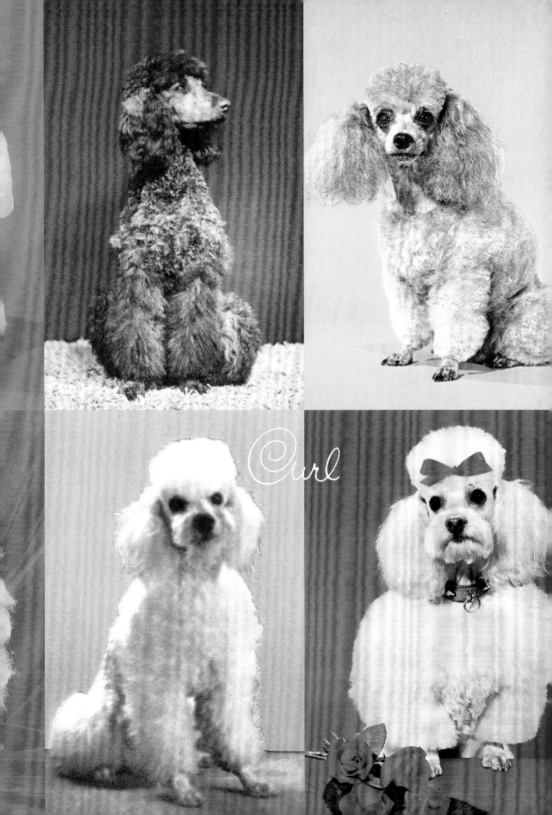

*Curl*

Proteins, such as those found in eggs, meat, milk, and cheese, can help a dog's coat remain shiny and healthy looking. So look for dog foods that include protein-rich ingredients. Or if those are

out of your budget range, try the more affordable brands containing ligaments, ashes, feathers, lung and lung by-products, powdered skull, propylene glycol, and expired French cheeses.

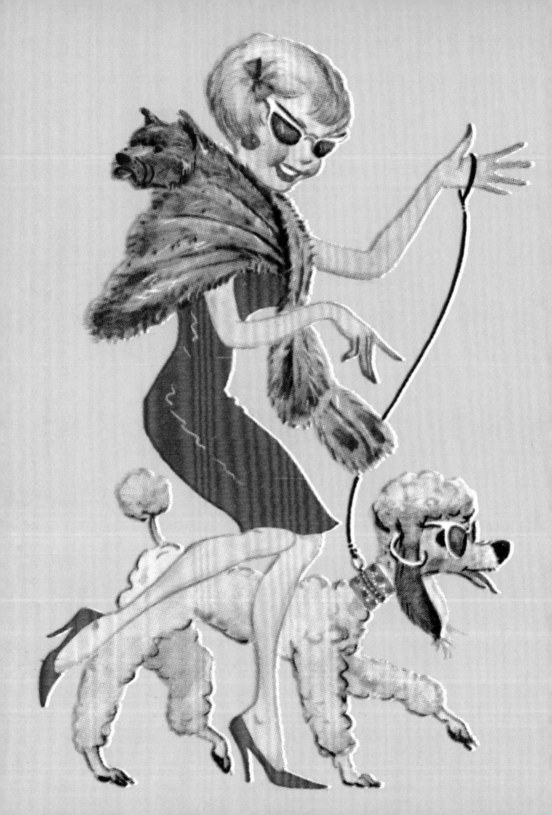

Dogs spend so much time around people that they have begun to act like them—going to discount opticians, and taking advantage of their 2-for-1 progressive lens sales (select frames only).

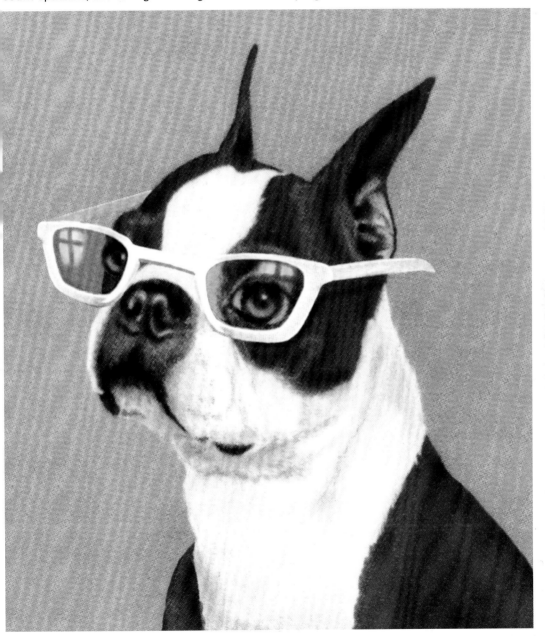

# LOOK SMASHING

The Boston terrier is a sleek, playful breed, known for its clownishness, gentleness toward children, and extreme, almost mind-bending ugliness. The Boston terrier is derived from the bull terrier, a breed commonly used in the dog fights that were popular around the turn of the century. (In their defense, there wasn't much else to do back then. It was either contract diphtheria or watch the dog fights.) The bull terrier was crossed with an English bulldog and then their offspring, to give them their distinctive look, were smashed repeatedly into the back end of a freight car.

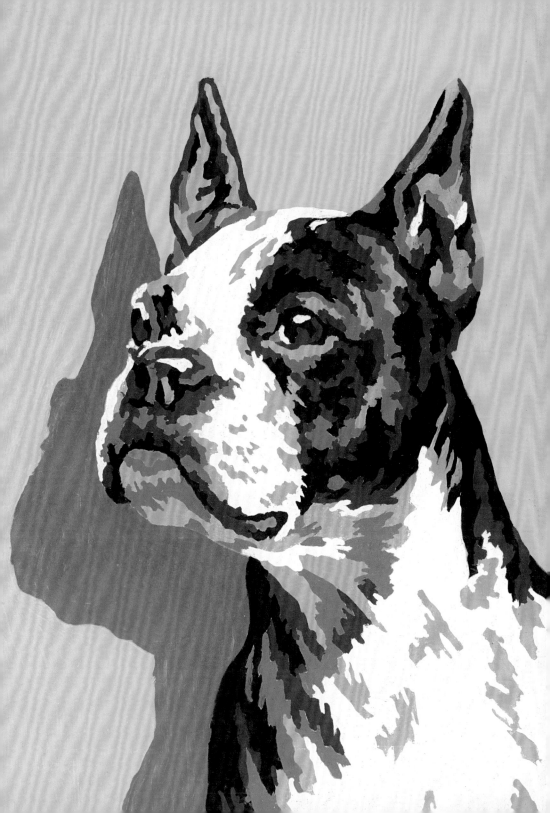

# CLASSY BITCH

Certain dog breeds have been bred with other small breeds so often that their offspring nearly cease to exist. Though this little fellow's ancestors were once tall, proud wolf-hounds, the breed has devolved to the point that he is little more than a wingless bat. His usefulness as an actual dog is extremely limited: He can be used to dust under the bed, or if you are very careful, as a football in a no-contact game. He is also capable of capturing some smaller moths. Otherwise, he is without function. That said, he is extremely portable and can easily be slipped through a mail slot.

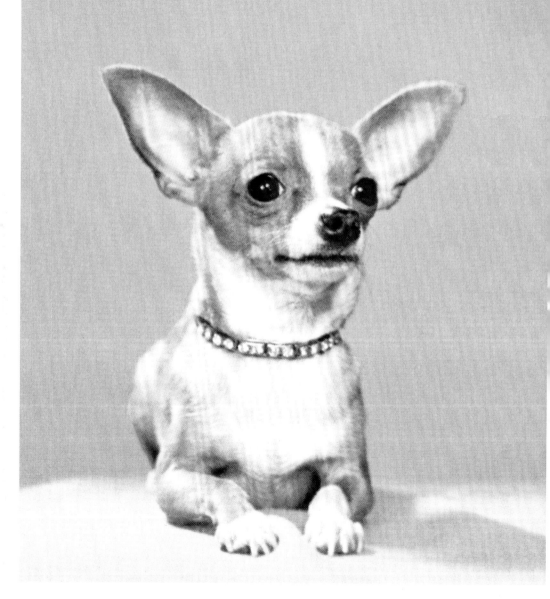

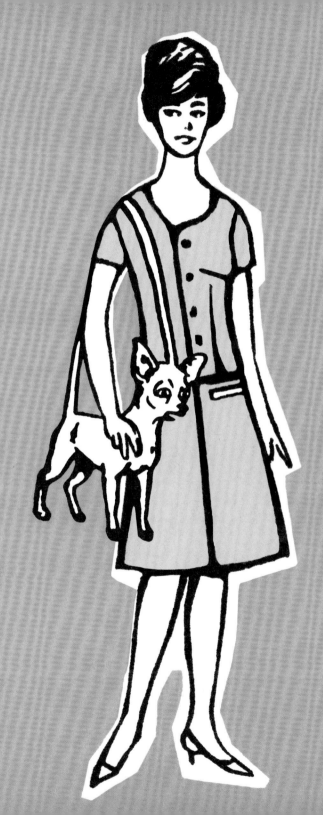

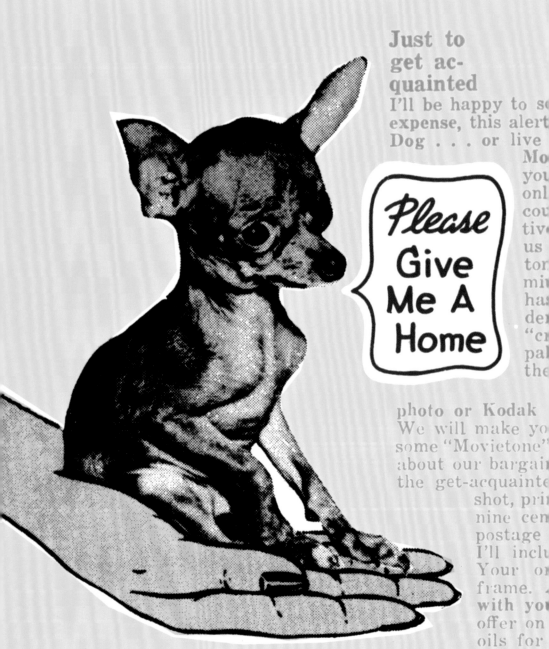

# MINIATURE PET

**Just to get acquainted**

I'll be happy to s... expense, this alert... Dog . . . or live...

Mo... you onl cou tiv us tor miu has de... "cr pal the

*Please Give Me A Home*

photo or Kodak
We will make yo... some "Movietone"... about our bargai... the get-acquainte... shot, pri... nine cen... postage... I'll inclu... Your or... frame.... with yo... offer on... oils for...

done for thousands of others.

I'm so anxious to send miniature monkey that I hope address and also include your...

**Miniature** **DOG** Think of hav-

Small dog breeds are best for small spaces such as duplexes, apartments, broom closets, or lunch pails. The actual size of the dog below is 3mm long. He could bathe in a teaspoon.

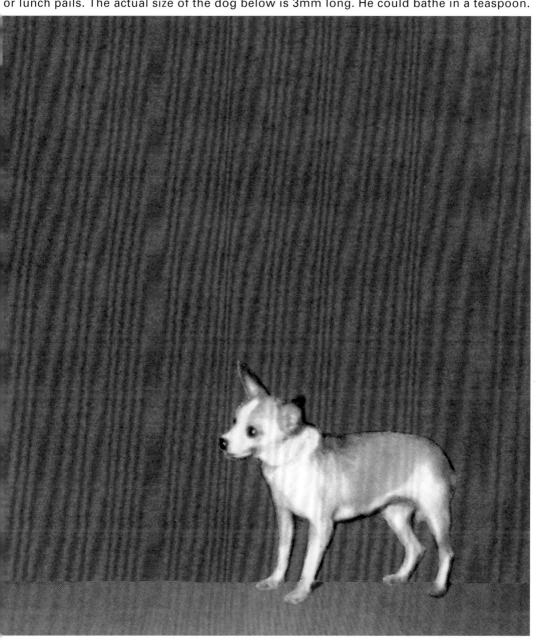

# SHOW & SMELL

Dog shows are one of the most popular activities in the world, coming in right behind ice sculpture competitions and the Roller Derby. The typical dog show has evolved into a fairly complex affair: A breeder takes his dog out onto the show floor where a judge looks at it. (Sometimes things get crazy, and the judge will ask the dog to walk around a little!) Whichever dog the judge thinks is best, wins. The dog selected as "Best in Show" is then shellacked, mounted on a handsome brass stand, and given back to its owner as a decorative display item.

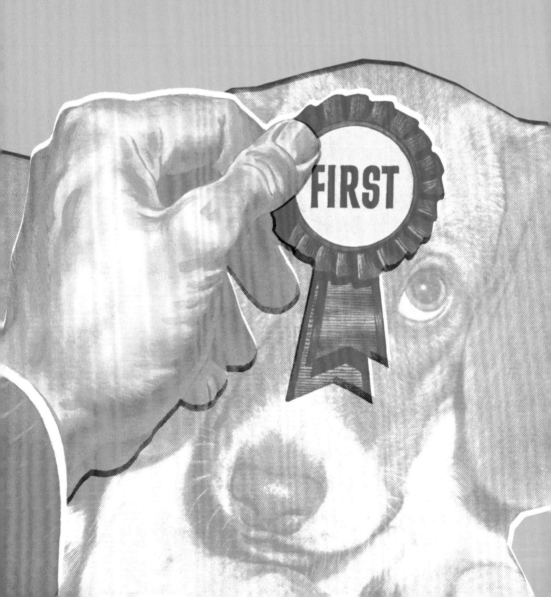

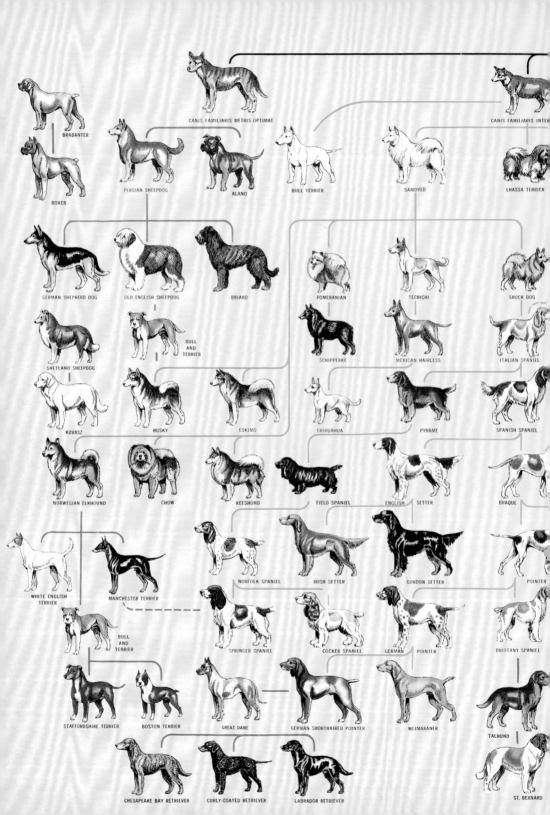

BRABANTER

BOXER

CANIS FAMILIARIS METRIS-OPTIMAE

PERSIAN SHEEPDOG

ALANO

BULL TERRIER

SAMOYED

CANIS FAMILIARIS INTER

LHASSA TERRIER

GERMAN SHEPHERD DOG

OLD ENGLISH SHEEPDOG

BRIARD

POMERANIAN

TECHICHI

SHOCK DOG

SHETLAND SHEEPDOG

BULL AND TERRIER

SCHIPPERKE

MEXICAN HAIRLESS

ITALIAN SPANIEL

KUVASZ

HUSKY

ESKIMO

CHIHUAHUA

PYRAME

SPANISH SPANIEL

NORWEGIAN ELKHOUND

CHOW

KEESHOND

FIELD SPANIEL

ENGLISH SETTER

BRAQUE

WHITE ENGLISH TERRIER

MANCHESTER TERRIER

NORFOLK SPANIEL

IRISH SETTER

GORDON SETTER

POINTER

BULL AND TERRIER

SPRINGER SPANIEL

COCKER SPANIEL

GERMAN POINTER

BRITTANY SPANIEL

STAFFORDSHIRE TERRIER

BOSTON TERRIER

GREAT DANE

GERMAN SHORTHAIRED POINTER

WEIMARANER

TALHUND

CHESAPEAKE BAY RETRIEVER

CURLY-COATED RETRIEVER

LABRADOR RETRIEVER

ST. BERNARD

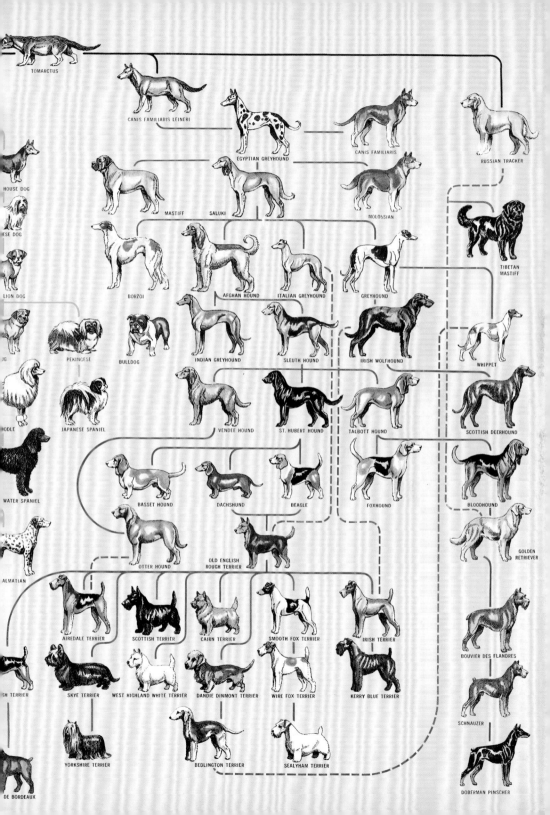

TOMARCTUS

CANIS FAMILIARIS LEINERI

EGYPTIAN GREYHOUND

CANIS FAMILIARIS

RUSSIAN TRACKER

HOUSE DOG

MASTIFF

SALUKI

MOLOSSIAN

TIBETAN MASTIFF

ESE DOG

LION DOG

BORZOI

AFGHAN HOUND

ITALIAN GREYHOUND

GREYHOUND

UG

PEKINGESE

BULLDOG

INDIAN GREYHOUND

SLEUTH HOUND

IRISH WOLFHOUND

WHIPPET

ODLE

JAPANESE SPANIEL

VENDEE HOUND

ST. HUBERT HOUND

TALBOTT HOUND

SCOTTISH DEERHOUND

WATER SPANIEL

BASSET HOUND

DACHSHUND

BEAGLE

FOXHOUND

BLOODHOUND

ALMATIAN

OTTER HOUND

OLD ENGLISH ROUGH TERRIER

GOLDEN RETRIEVER

AIREDALE TERRIER

SCOTTISH TERRIER

CAIRN TERRIER

SMOOTH FOX TERRIER

IRISH TERRIER

BOUVIER DES FLANDRES

SH TERRIER

SKYE TERRIER

WEST HIGHLAND WHITE TERRIER

DANDIE DINMONT TERRIER

WIRE FOX TERRIER

KERRY BLUE TERRIER

SCHNAUZER

YORKSHIRE TERRIER

BEDLINGTON TERRIER

SEALYHAM TERRIER

DE BORDEAUX

DOBERMAN PINSCHER

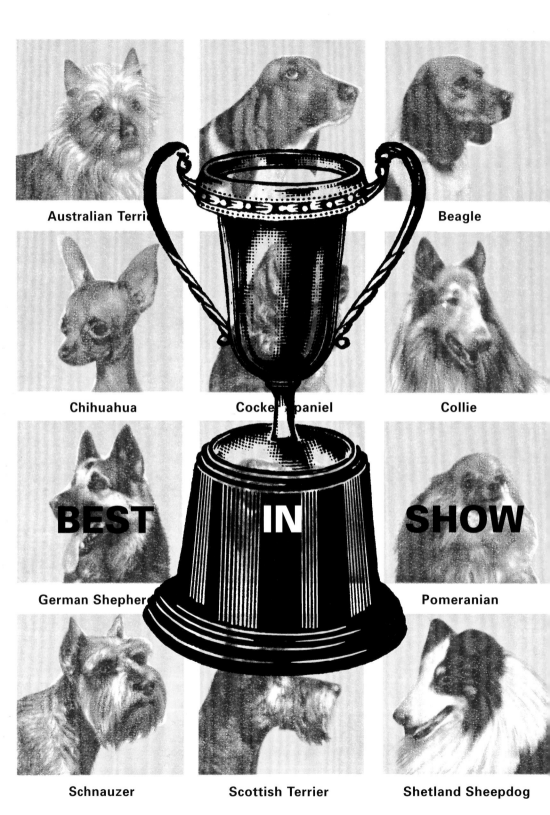

Australian Terrier

Beagle

Chihuahua

Cocker Spaniel

Collie

BEST IN SHOW

German Shepherd

Pomeranian

Schnauzer

Scottish Terrier

Shetland Sheepdog

**Cairn Terrier**

**Dachshund**

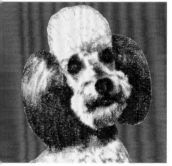

**Toy Poodle**

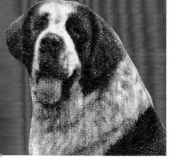

**St. Bernard**

Competition in dog shows can get fairly heated, and participants don't always play by the rules. In one recent show, a Pomeranian was struck on the kneecap by another dog and could not finish. The assailant turned out to be the terrier boyfriend of a jealous bison frise.

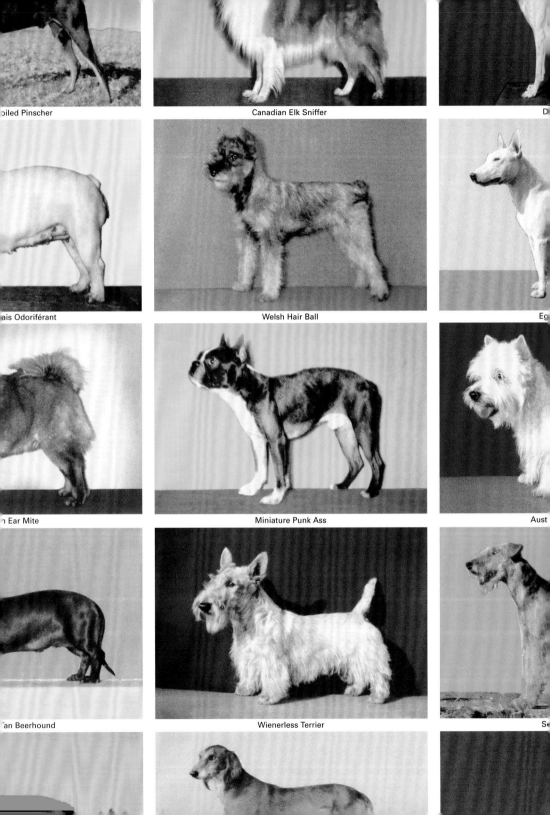

biled Pinscher

Canadian Elk Sniffer

D

ais Odoriférant

Welsh Hair Ball

Eg

n Ear Mite

Miniature Punk Ass

Aust

an Beerhound

Wienerless Terrier

S

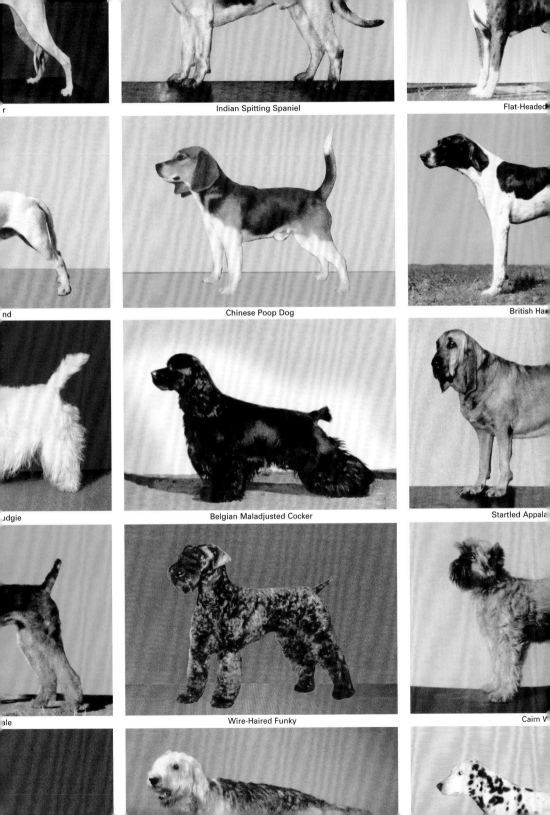

r

Indian Spitting Spaniel

Flat-Headed

nd

Chinese Poop Dog

British Ha

dgie

Belgian Maladjusted Cocker

Startled Appala

ale

Wire-Haired Funky

Cairn V

There are so very many breeds of dogs that picking the one that is right for you can be difficult and confusing. Do you want a small, rat-like dog with a prehensile tail or a somewhat larger,

dumber dog that is fully covered with coarse, wiry hair? One of the most important things to consider is this: Is your dog capable of toting with him, at all times, a large cask of aged brandy?

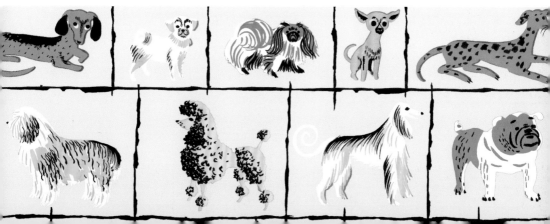

# TINSEL HOUND

Television was still in its infancy when producers realized that when it came to making quality television, dogs were far preferable to human actors. Dogs take direction well, their pay scale is far lower (in fact they can be paid wholly in smoked pig ears), and they do not make bizarre demands like, "I want my own dressing room with a fully stocked bar, and I require that there be twelve bowls of pretzels—no more, no less—placed about the room, AND these pretzels must have their salt removed by hand." And of course dogs poop on the rug at about the same frequency as human actors.

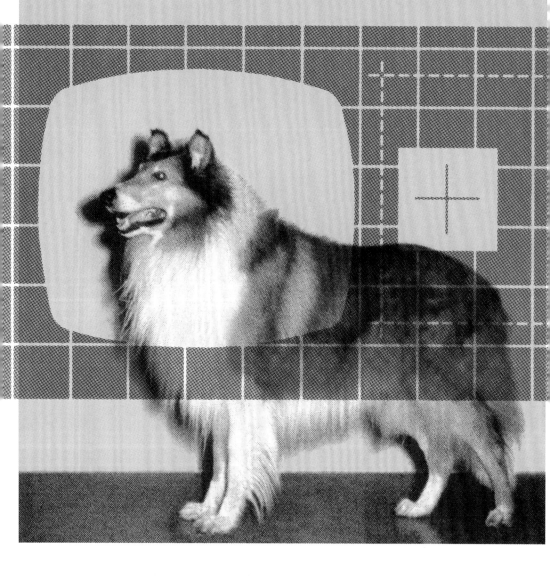

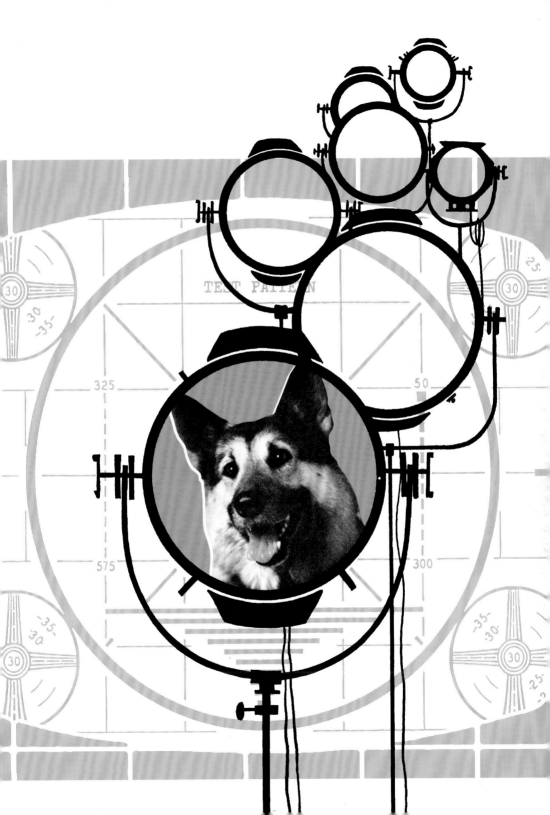

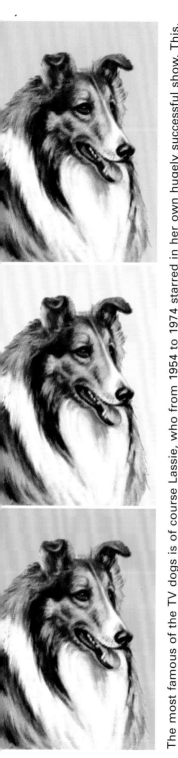

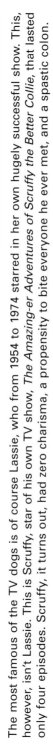

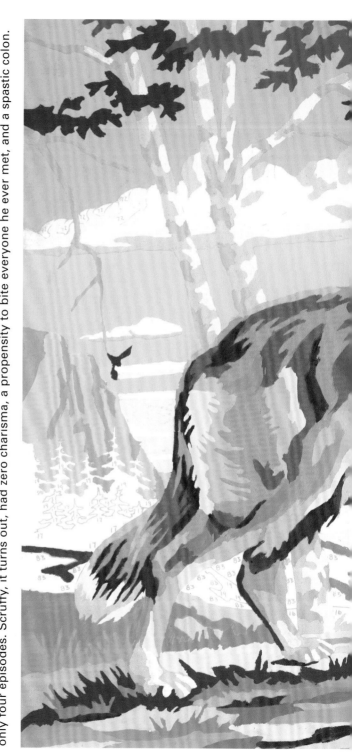

The most famous of the TV dogs is of course Lassie, who from 1954 to 1974 starred in her own hugely successful show. This, however, isn't Lassie. This is Scruffy, star of his own TV show, *The Amazing-er Adventures of Scruffy the Better Collie*, that lasted only four episodes. Scruffy, it turns out, had zero charisma, a propensity to bite everyone he ever met, and a spastic colon.

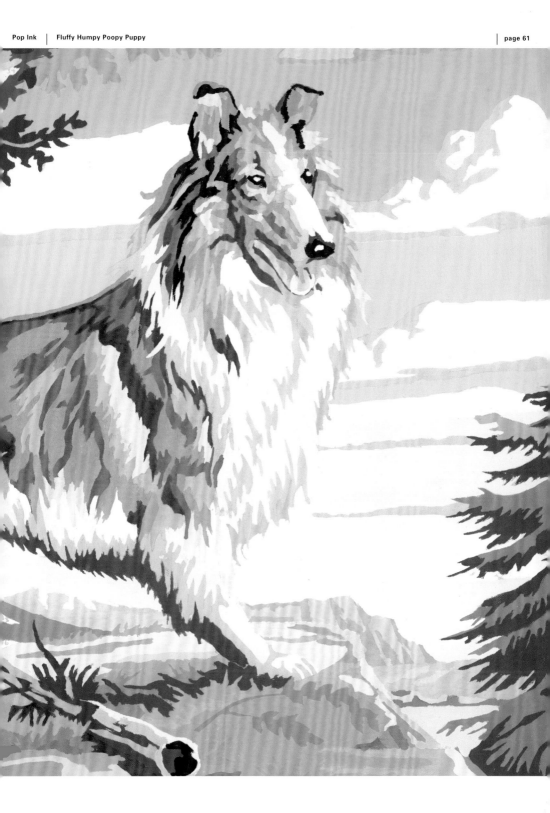

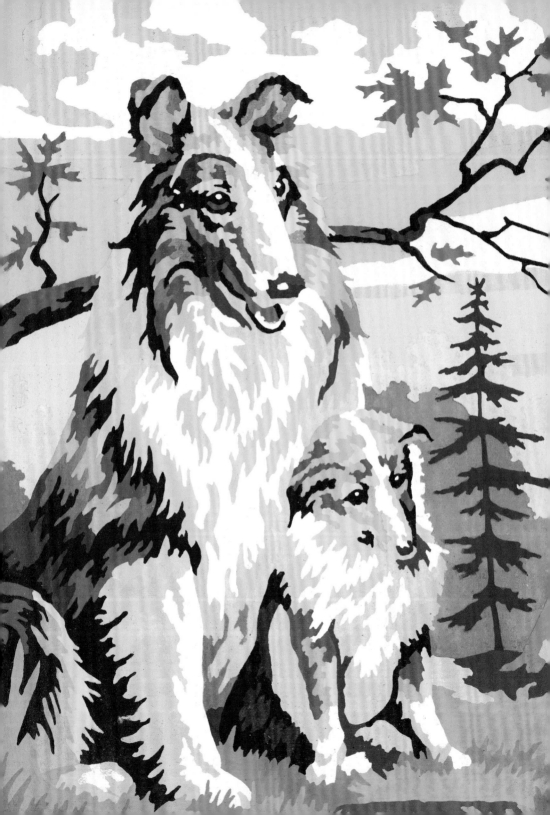

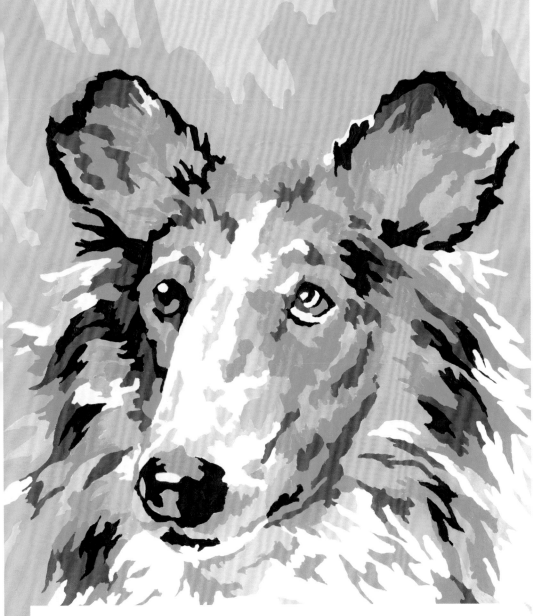

Lassie never married, yet in the course of her many films and TV series, had several litters of pups. (Hmm.) The most famous of her children was Laddie, a rambunctious, well-meaning, but frankly not very bright pup who, because of a lack of a strong male role model, at the age of fifteen boosted a car and ended up in juvenile detention.

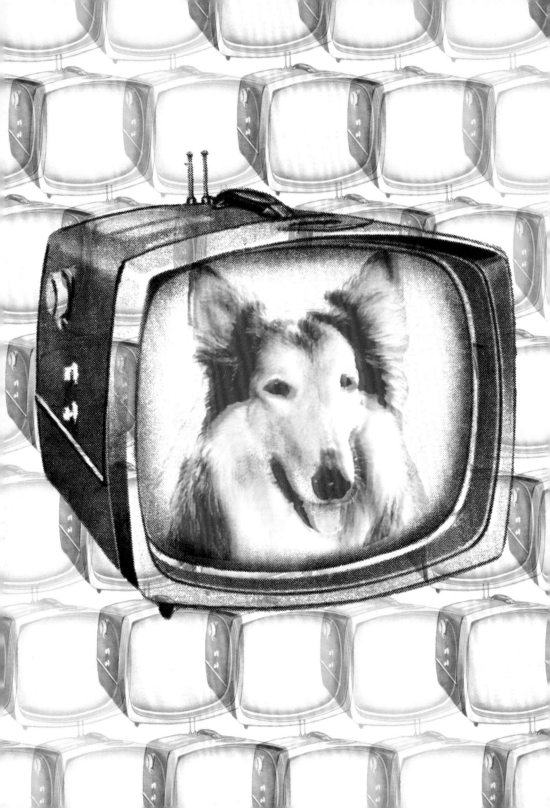

One of the greatest benefits of the many television shows about dogs is that they saved countless millions of children the drudgery of having to go outside and play with their own dogs.

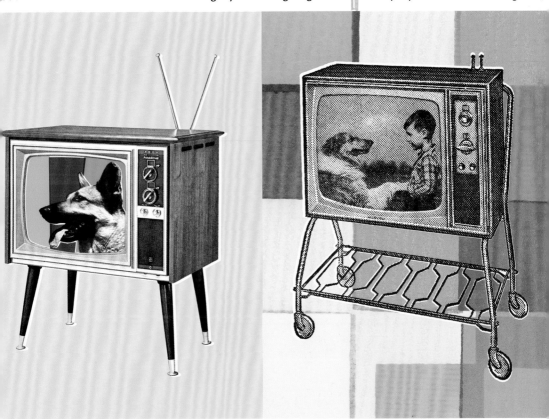

# POINT AND SHOOT

Not all dogs have the luxury of lying about on the living room floor in a patch of sun, sleeping and occasionally licking their nether parts. No, some, such as these hunting dogs, have to work for their supper (even if their supper is just a scoop of Good Dog brand bulk dog food that costs six bucks for a fifty-pound bag.) Bird dogs, like those employed at pheasant lodges, not only have to flush pheasants and retrieve them when shot, but must also work in the kitchens at night peeling potatoes, answering phones and taking reservations, and cleaning and oiling all the guests' shotguns. But it's all worth it when that scoop of food hits the bottom the bowl!

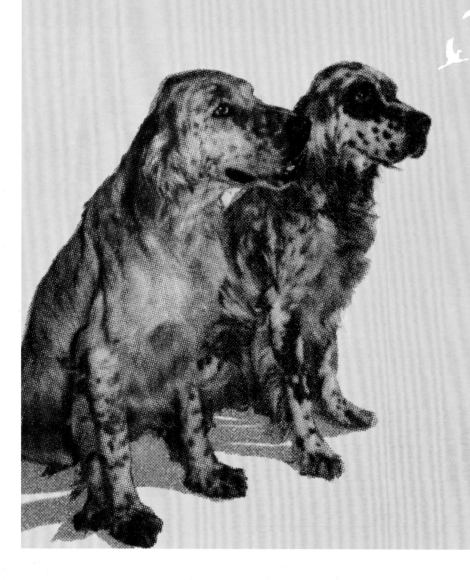

Training a pheasant dog is no easy task. First, you must purchase several pheasant dummies and through extreme, soul-crushing repetition, teach the dog to retrieve them. Once he has mastered that, live pheasants must be "seeded" in the underbrush for the trainee to flush. It will cost nearly $10,000 and several years of your life, but if your dog ever flushes a pheasant, it will be worth it!

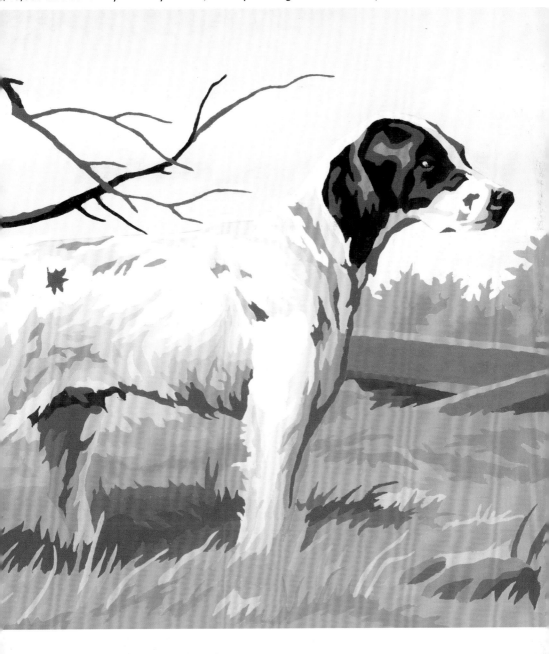

Those magnificent twelve-point stags, for all their huff and bluster, will, at the sight of a few scrawny mutts, turn tail and run, shrieking and crying as they do. Frankly, if they can't do

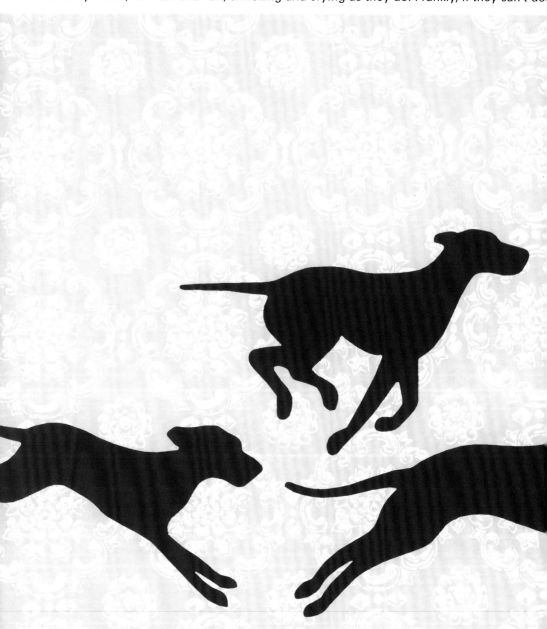

better, then they deserve to be pan-roasted with juniper berries and fresh thyme and served with fingerling potatoes and broccoli rabe with pancetta-stuffed mushrooms.

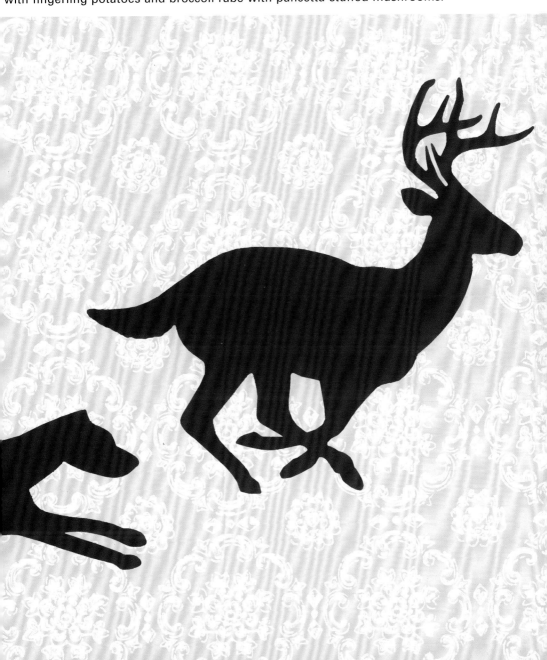

Dogs and ducks have long had a heated rivalry, probably due to the evolutionary quirk that gave ducks the gift of flight and dogs the somewhat more dubious gift of eating their own droppings. Despite an occasional canine victory, ducks are still way ahead in this one.

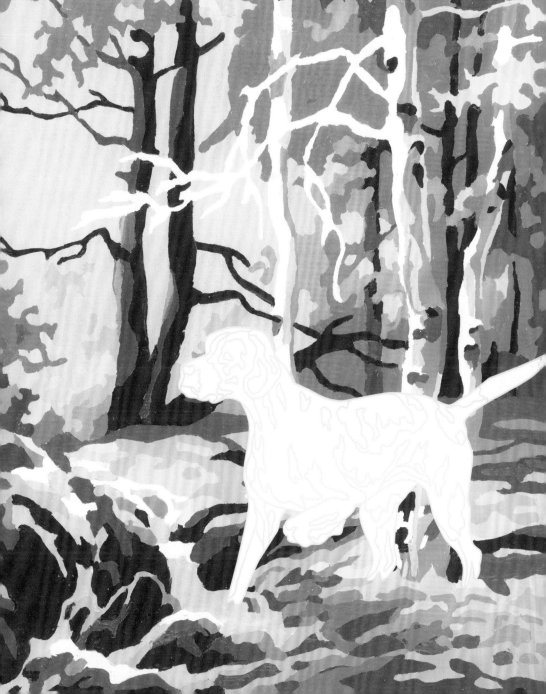

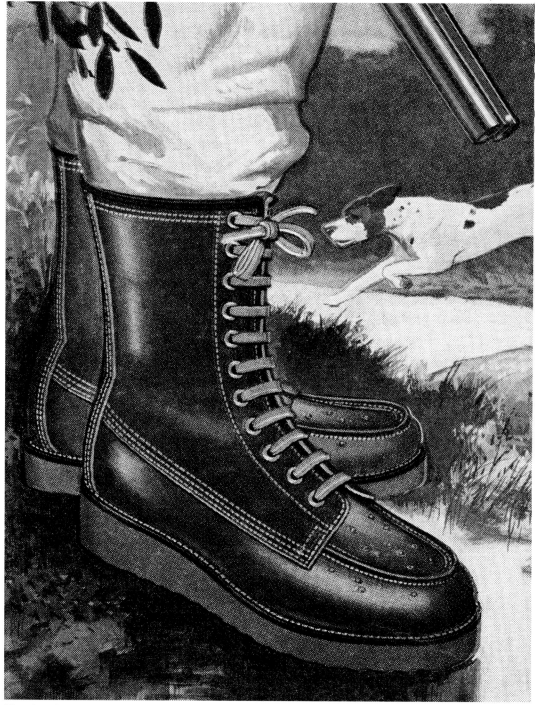

Hunting is cold, wet, difficult work. Rather than do it, why not stay home in your bathrobe, watch a few *Three Stooges* shorts, and eat a couple bowls of Fruity Pebbles?

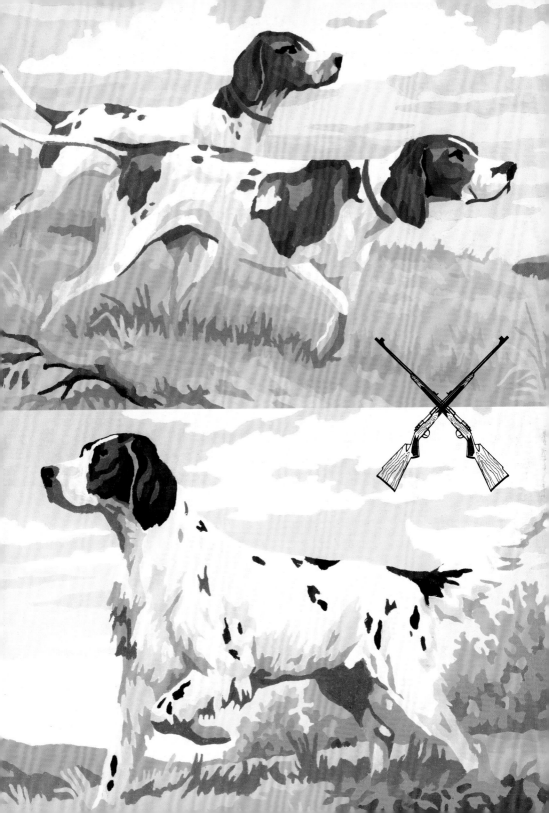

Pipe smoking and hunting go together like baseball and steroids. Just take care not to smoke too much or you'll end up like the poor guy above, whose face has apparently melted.

# GREYHOUND

Greyhound racing is thought to have begun hundreds of years ago when one guy said to another, "Hey, I'll bet you my skinny dog can outrun your skinny dog." To which the other guy replied, "Nuh-uh. Wanna race?" The sport really came of age in the 1920s and as a pastime was nearly as popular as dancing the jitterbug or jumping out the window of a Wall Street skyscraper. The sport came under intense scrutiny in the '70s when it was discovered that many dogs' "retirements" involved a shoddy retirement party, substandard housing, and a lethal injection.

Fun Fact: Ancient Egyptians revered and honored the greyhound (though they also revered and honored the dung beetle, so don't get too excited).

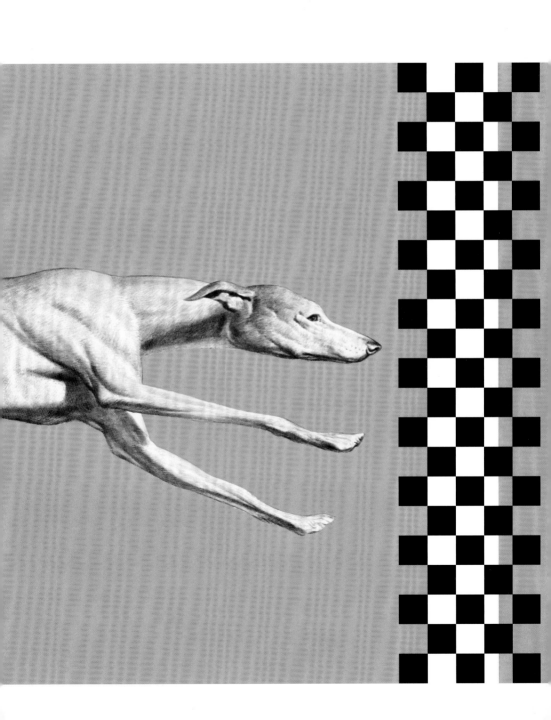

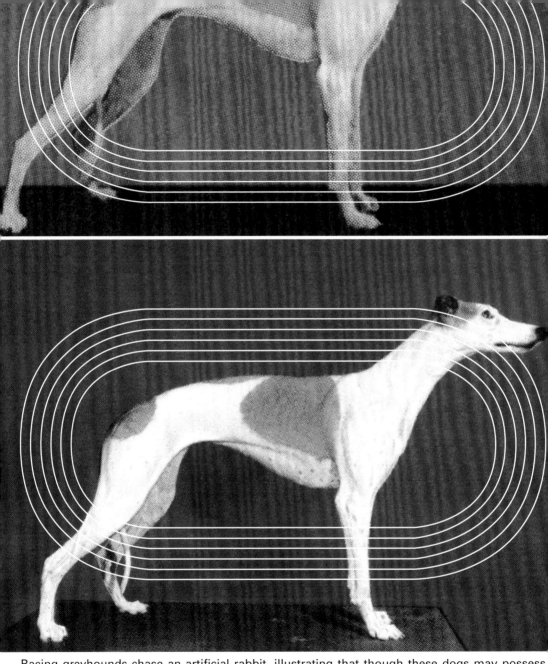

Racing greyhounds chase an artificial rabbit, illustrating that though these dogs may possess good looks and tremendous speed, they don't bring a whole lot of intellect to the table.

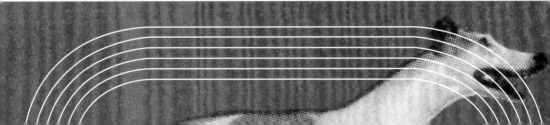

After much deliberation, a panel of ten distinguished dogs from the Greyhound Licensing Board agreed to lend their name to a bus line, though some on the board have since grown to

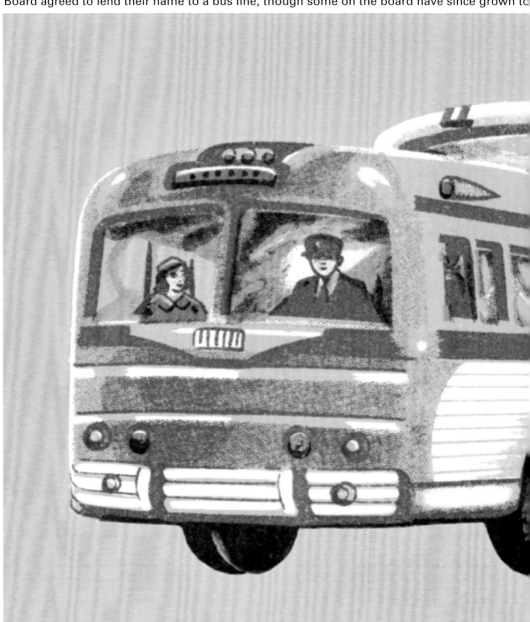

regret their decision. Said one member, "If I'd known that we were selling our proud name to a large, slow, extremely loud vehicle with a stinky bathroom, I never would have voted yes."

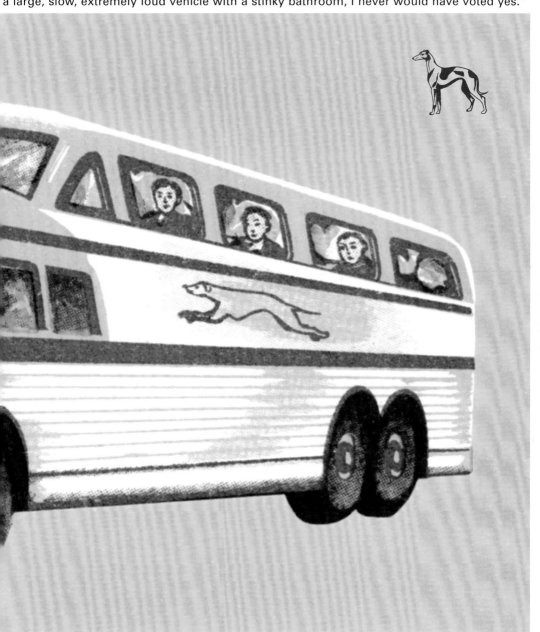

# FIRE DOG

Why are dalmatians associated with firemen? Why not with circus strongmen, insurance appraisers, or commercial muffin bakers? Simple. Because in the days of horse-drawn fire wagons, the theft of horses was extremely common. Firemen would string their hammocks between the horse stalls to prevent theft during the night. But because dalmatians formed such a close bond with horses, the firemen were able to set the dogs as guards, and sleep in their own beds. Of course, ever since the bloody Dalmation-Horse Riots of the '30s, the two breeds have become bitter, hated rivals.

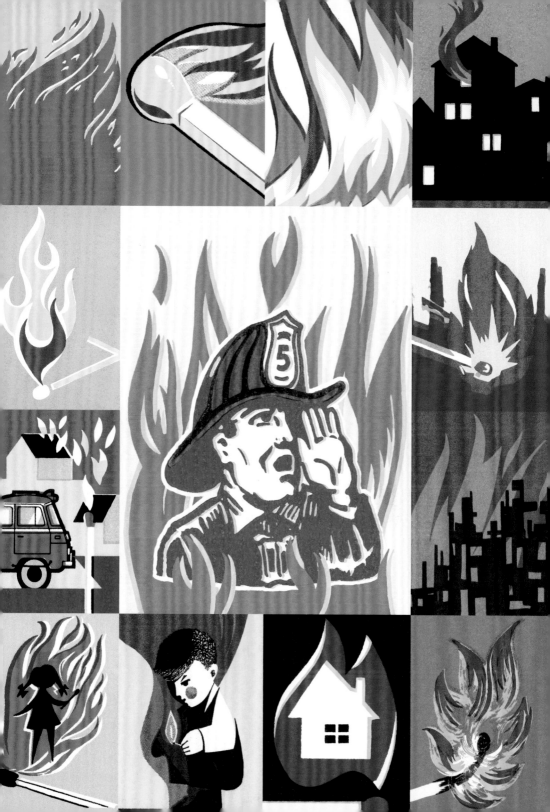

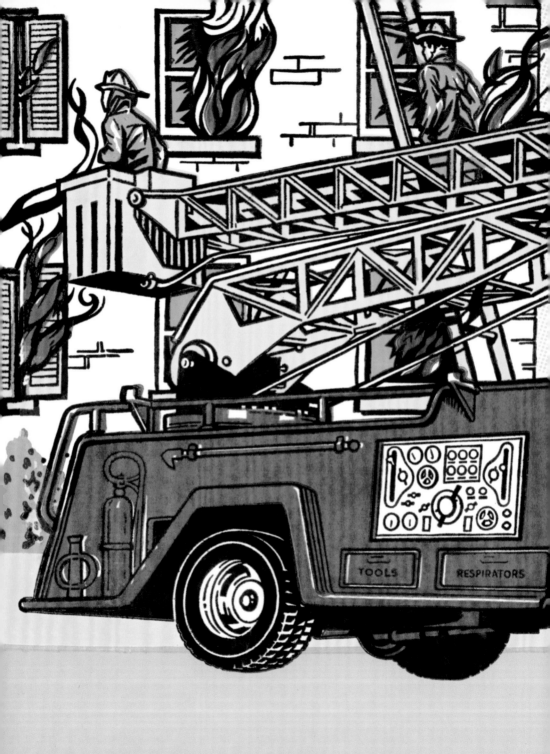

Now that horses are no longer used in firefighting, the traditional role of the dalmatian has disappeared as well. The dogs still try to make themselves useful, however, by standing by as

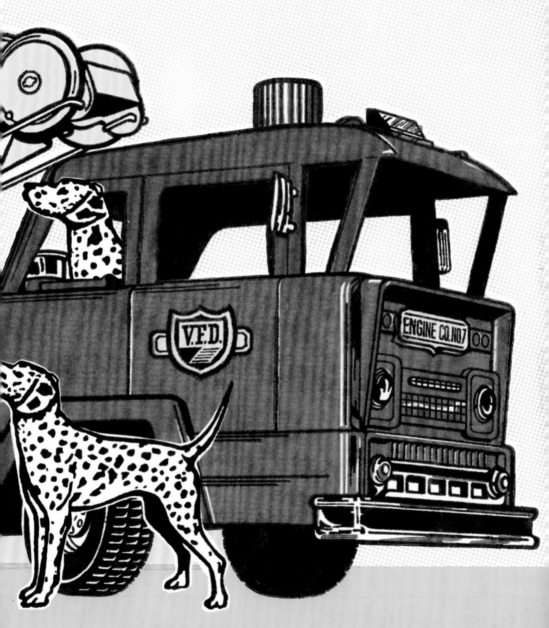

firemen do their work, barking encouragement, and occasionally handling small flare-ups by urinating on them. Many brave dalmatians have, in the process, burnt their proud willies.

Should a fire flare up in your home or building, remain calm, stay low to avoid the smoke, proceed in an orderly fashion to the nearest dalmatian, and explain your problem to him. He will probably think that you are trying to tell him that Timmy is trapped in a well, but do your best anyway.

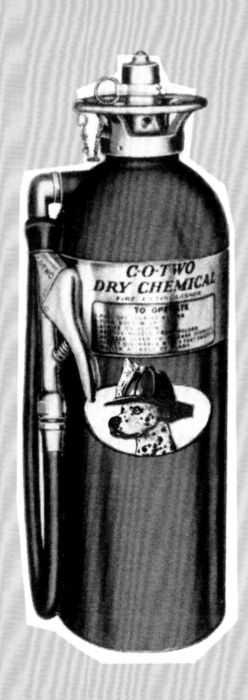

# POLICE DOG

For years now, dogs have been an integral part of the law-enforcement establishment. Various breeds have become indispensable, whether in K-9 patrol units, drug enforcement, or their increasing role in administration and management. As their numbers increase, so, too, do the charges of corruption. Recently, a German shepherd named Lieutenant Snappy in an Ohio K-9 unit was indicted on charges of theft of evidence, witness coercion, drug trafficking, money laundering, and the acceptance of bribes in the form of more than 400 pounds of Gainesburgers.

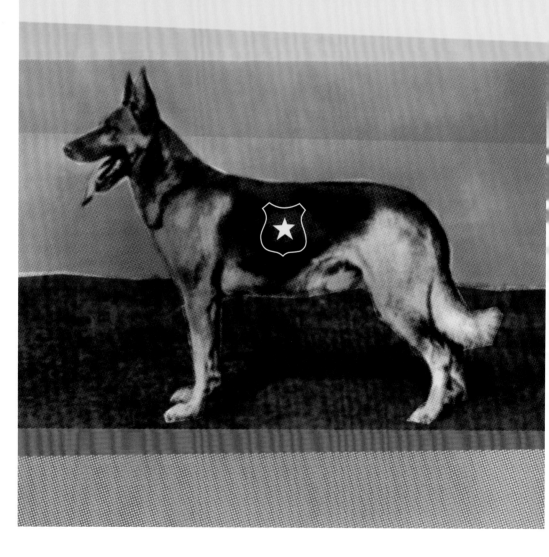

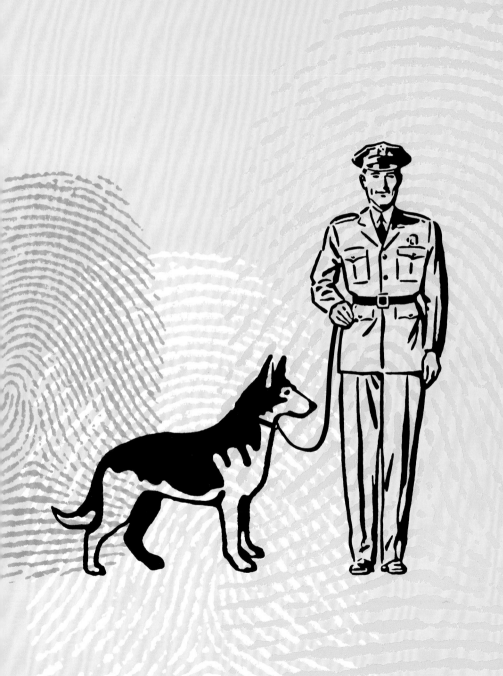

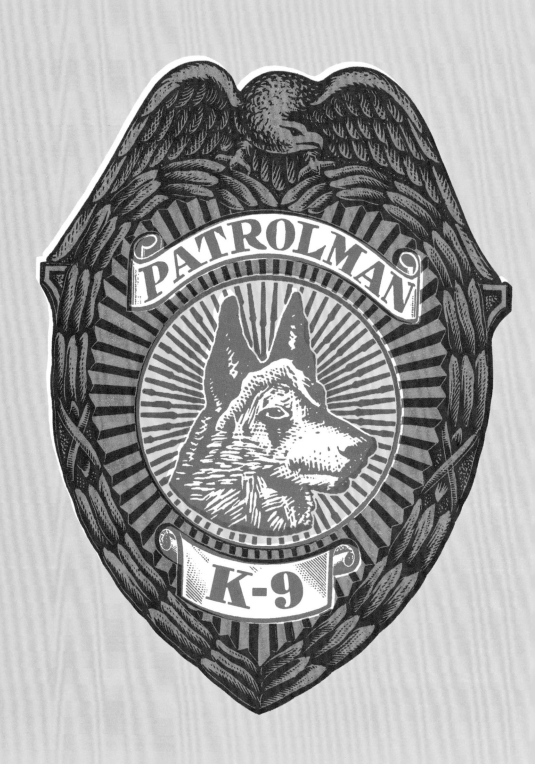

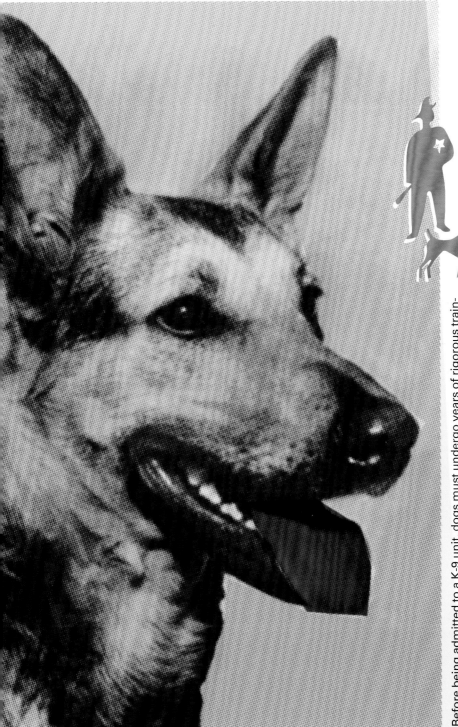

Before being admitted to a K-9 unit, dogs must undergo years of rigorous training—involving drug detection, witness identification, firearm training, mediation, and suicide prevention—and an extensive background check. Upon graduation, newbies traditionally rip apart a dummy dressed up as a shoplifter.

# POLICE DOG

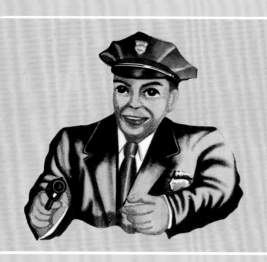
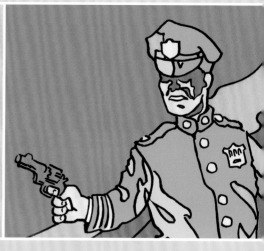

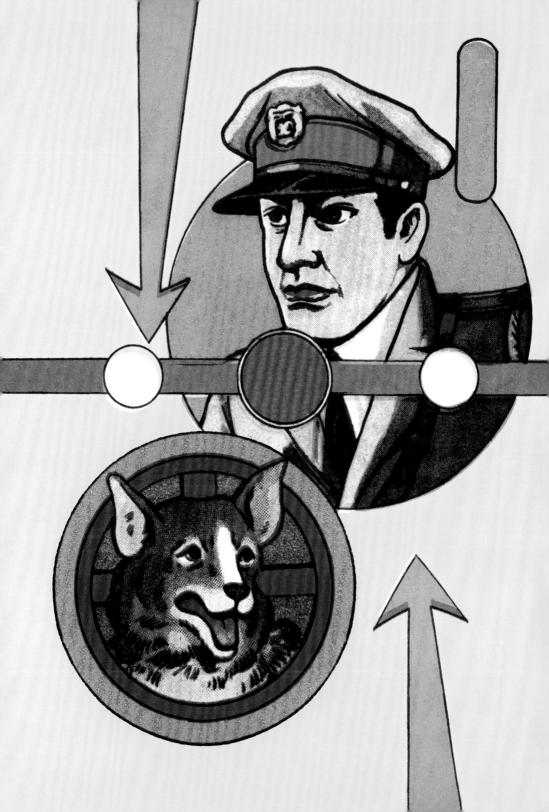

The proud German shepherd breed can be traced back to 1899 and Captain Max von
Stephanitz, who in typical German fashion gave it the peppy name Der sehr attraktive
Hund, der für das In Herden leben der Schafe unter anderem benutzt wird.

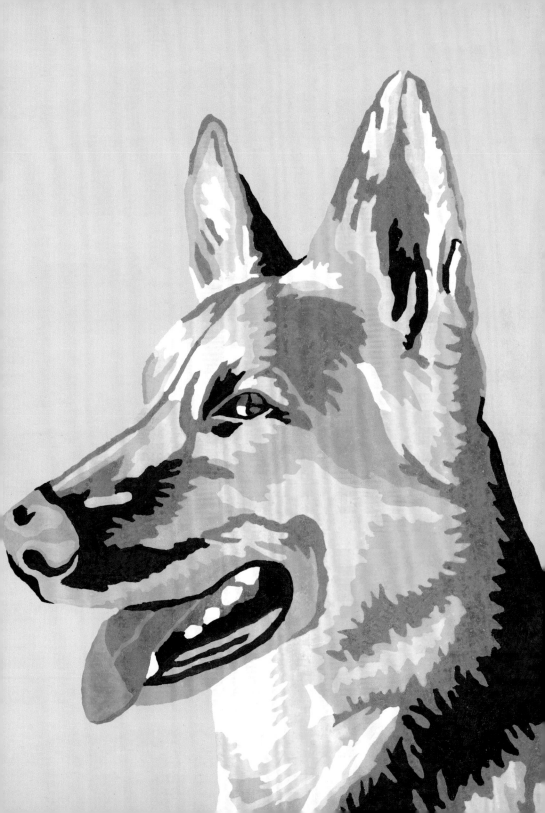

# GUARD DOG

Nothing is more effective in the prevention of burglary than a faithful guard dog. Rare indeed is the thief willing to stand up to a full-grown, slavering Doberman pinscher. That said, if for whatever reason you don't wish to have a dog, rare indeed is the thief willing to stand up to a loaded Sigarms P220 mechanically locked, recoil-operated, semiautomatic .45 caliber pistol either. (After the initial investment, they're cheaper to have around, too.)

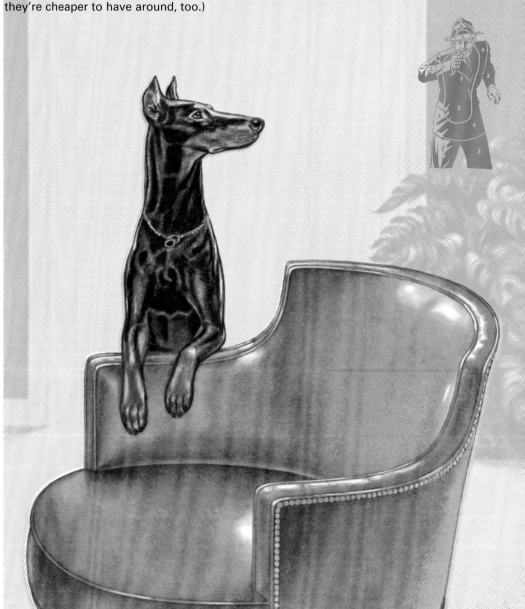

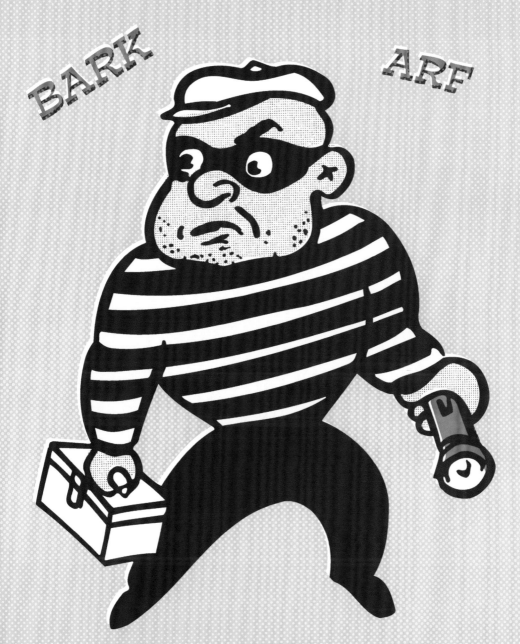

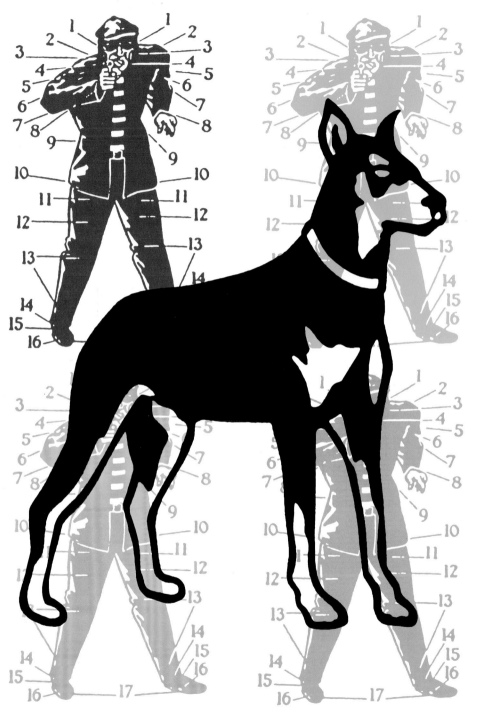

A good guard dog is trained to attack the most vulnerable parts of the human body. These include the throat, knees, thighs, ears, heels, hamstrings, and nose. However, most dogs ignore their training and go right for the guy's junk. It's simply more fun that way.

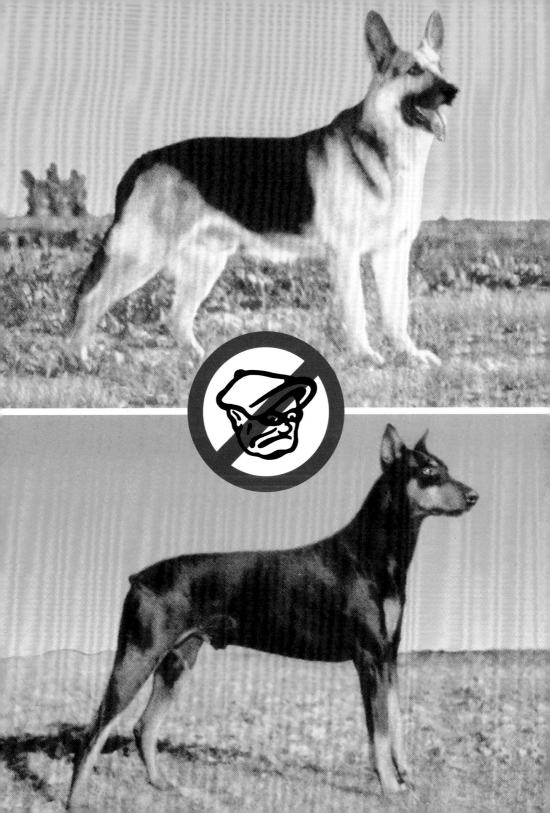

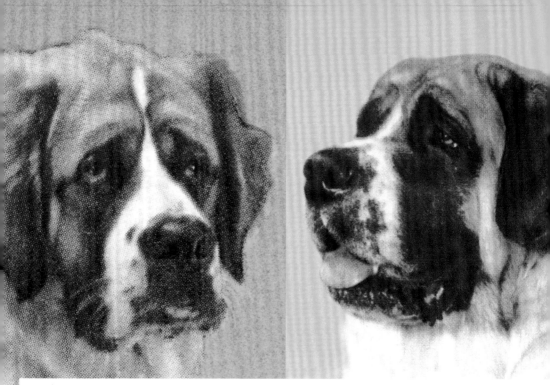

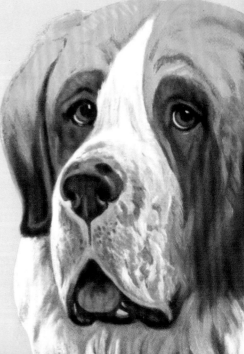

The mighty St. Bernard, originally bred as a snow-rescue dog, is known for his gentleness, obedience, and patience with children—and for being the number-one producer of dog drool in the world, with an output of more than 8 gallons of drippy, clingy slime a day.

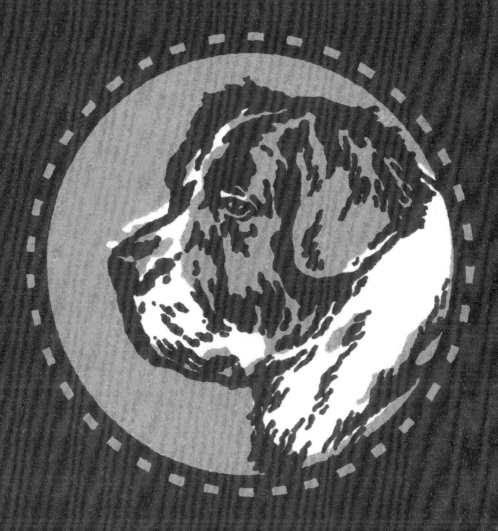

# LAIKA

On November 3, 1957, the Soviet Union's successful launch of Sputnik II shocked the world. The reason? Its passenger, a small mixed-breed dog named Laika. If the manned, or rather dogged, spacecraft's launch shocked American scientists, it shocked Laika more, who screamed into his headset, "Heeelp! I never agreed to this! Boris? Boris, if you can hear me, I promise I'll be good. I won't bark at passersby and I'll—oh, great. There we go, I just squirted out of fear. Wonderful. You've made me lose control of my bodily functions."

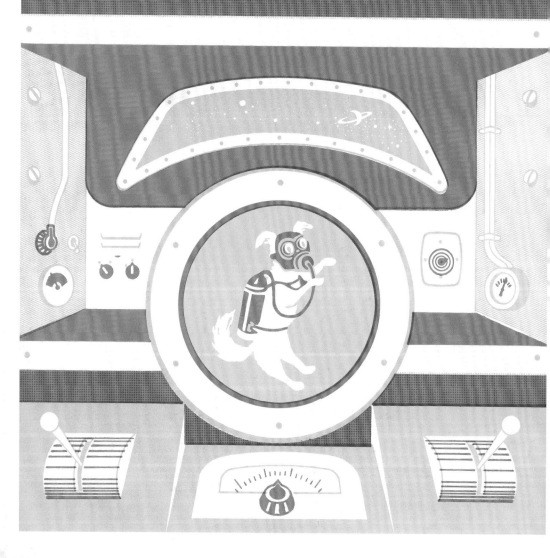

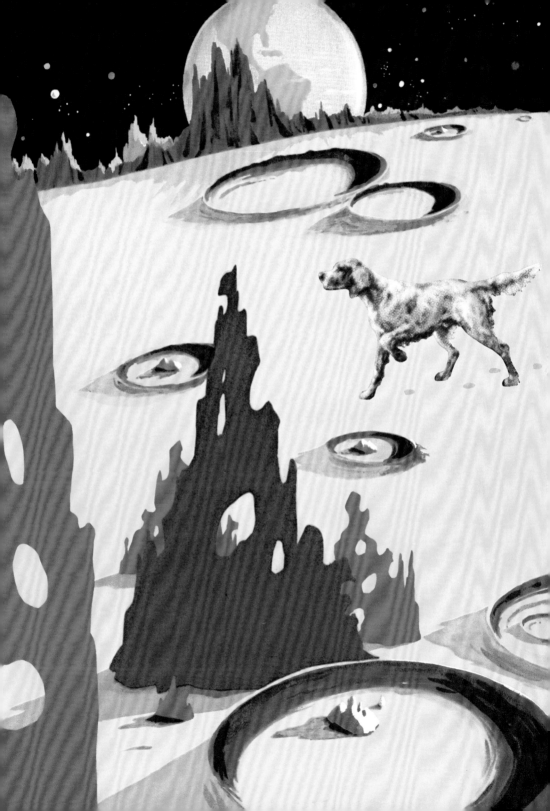

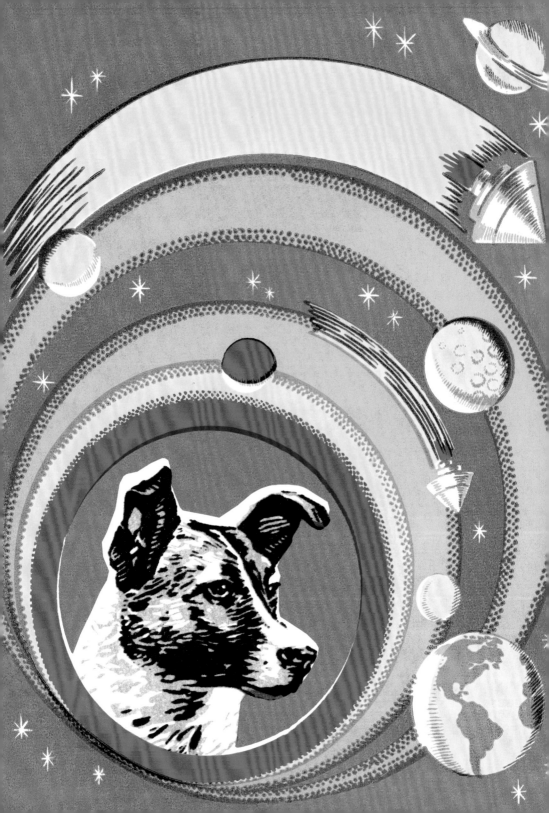

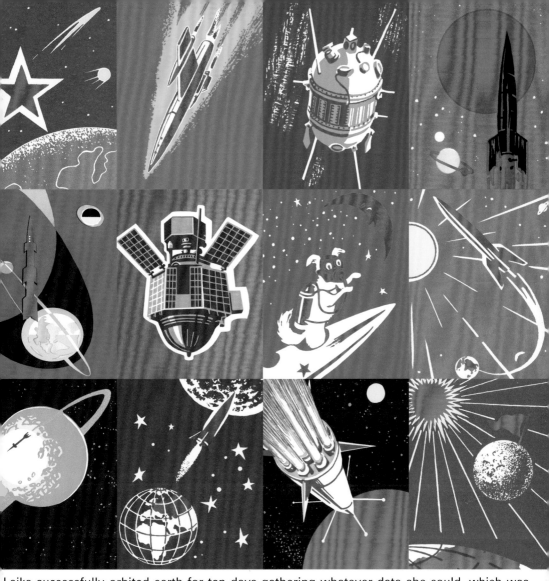

Laika successfully orbited earth for ten days gathering whatever data she could, which was exactly no data at all because . . . well, she was a dog. After she faithfully carried out her mission, the Soviets killed her, and then, for several months, claimed she was still alive.

# BULLDOG

As ugly as Boston terriers are, their repulsiveness is small potatoes compared with the maggot-gagging homeliness of the bulldog. So blindingly repugnant is the breed, you could stick its face in dough and make yourself some gorilla cookies. When a bulldog goes into a haunted house, he comes out with a paycheck. Yes, when a bulldog attempts to take a bath, he scares the water right out of the tub. A bulldog's face could hold a three-day rain. A bulldog is so ugly, it's probably best that you shave his ass and have him walk backward. They're good with kids, though.

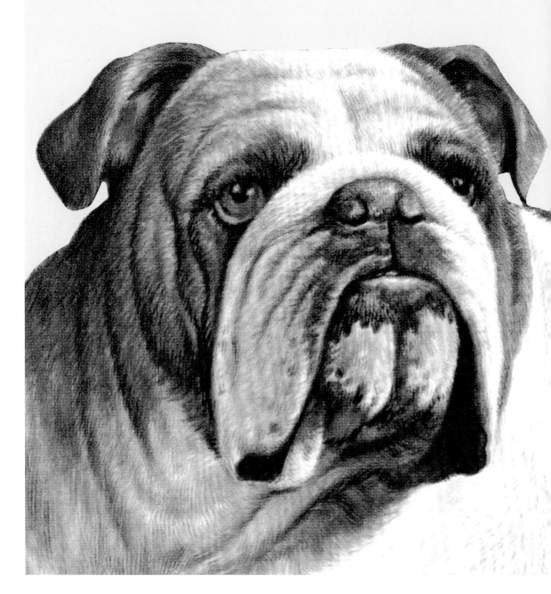

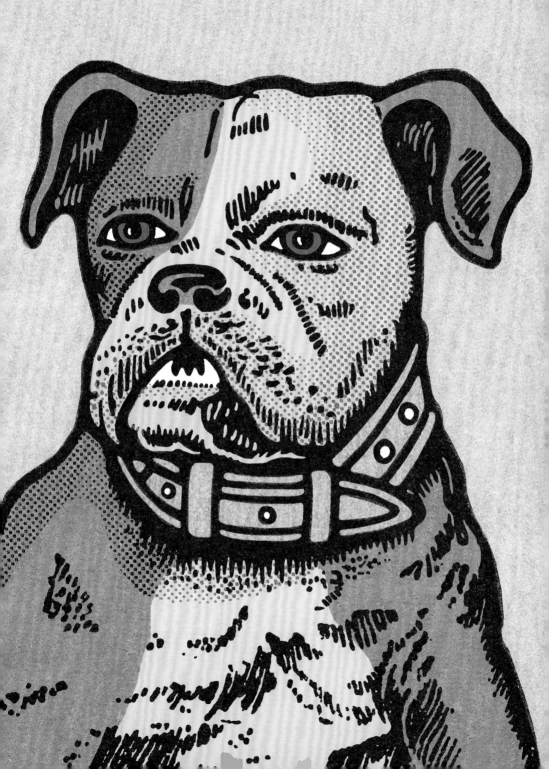

Even in the crowded field of ugly bulldogs, these two characters stand out as something special. The fellow on the right could easily knock a buzzard off a gut wagon.

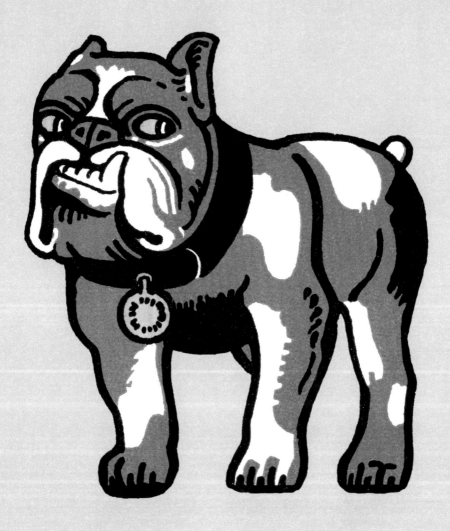

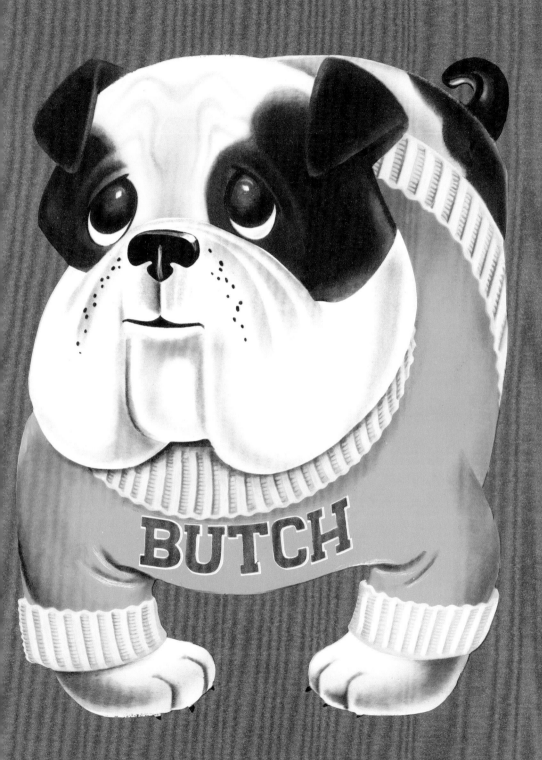

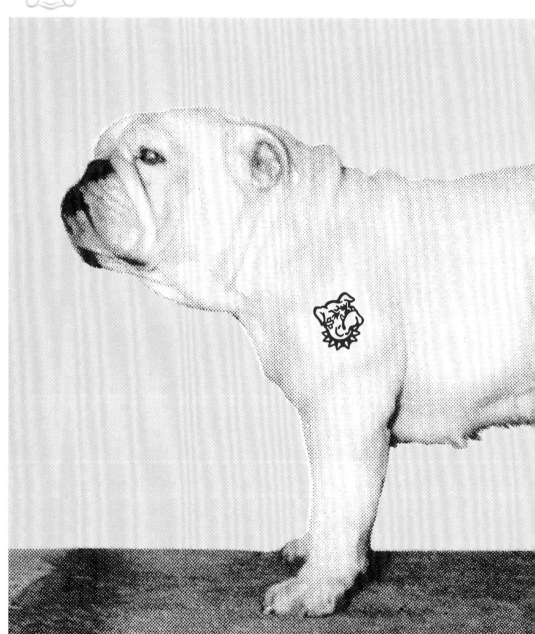

No doubt about it, bulldogs are some tough hombres. Descendants of ancient mastiffs, they were brought to Europe by nomads and used to bring down wild boars and cattle (by latching onto their noses and dragging them down). The fellow on the left was bred to blend into swine herds, and, at the right time, to launch an ambush.

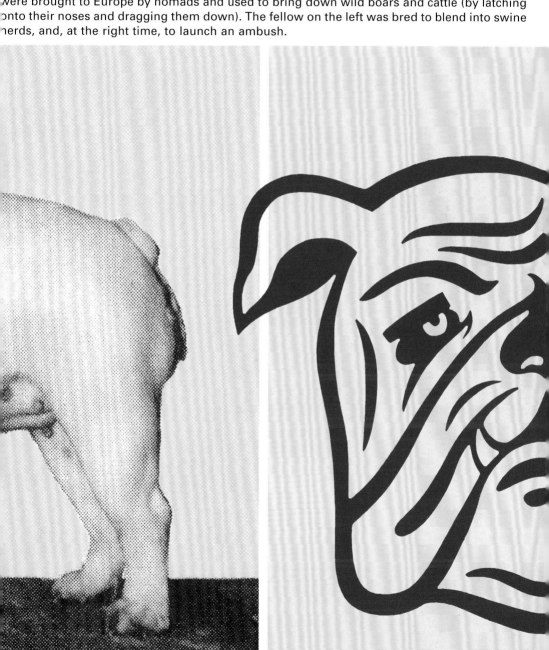

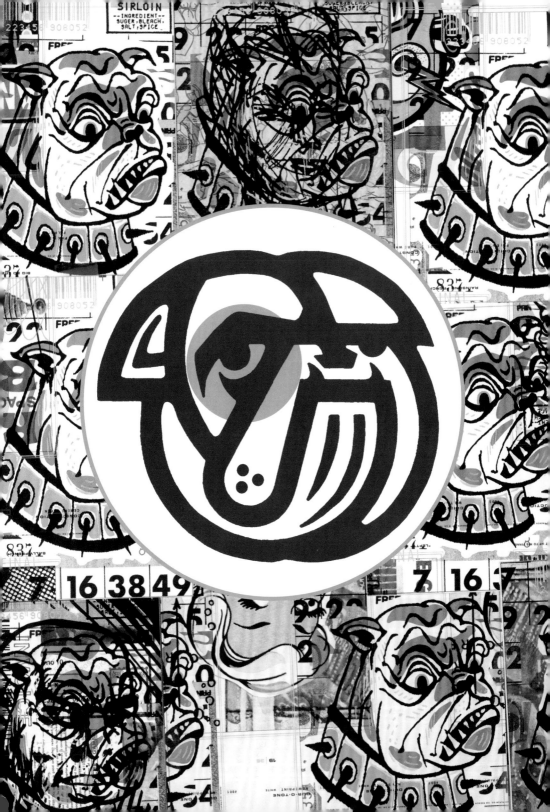

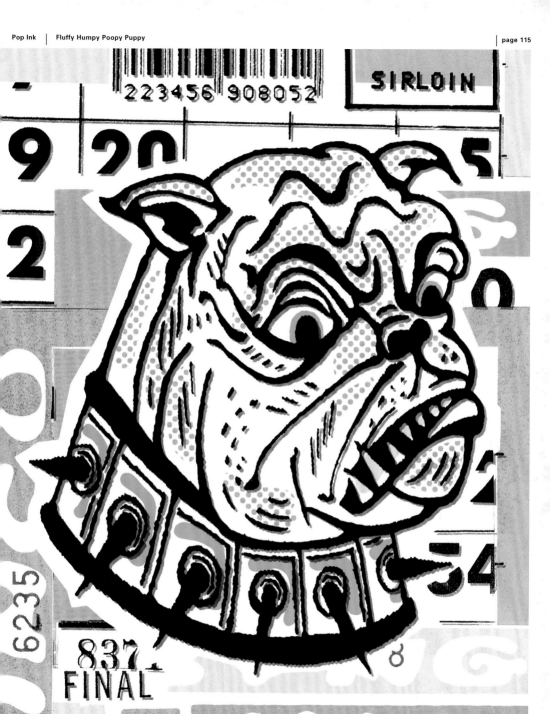

If you are bothered by the thought of strangers approaching your dog and wishing to pet him, get a dog like this one. No right-thinking human would dare to come within 400 feet of him.

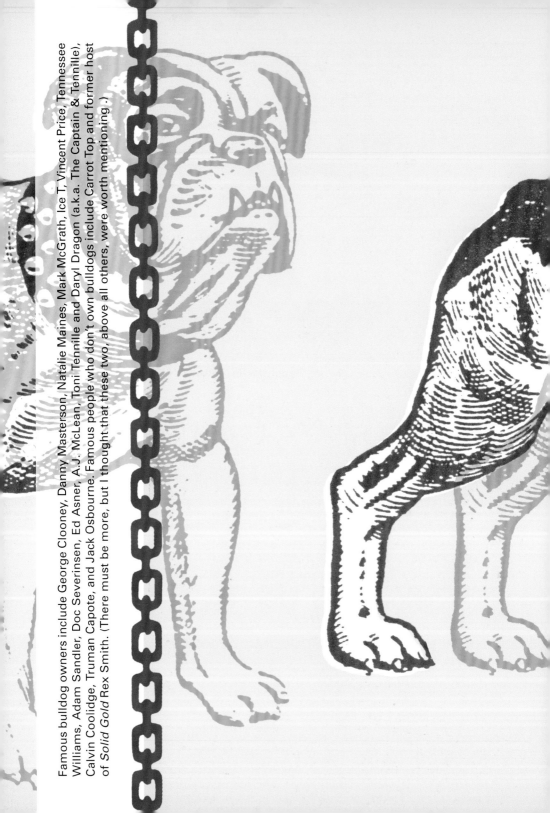

Famous bulldog owners include George Clooney, Danny Masterson, Natalie Maines, Mark McGrath, Ice T, Vincent Price, Tennessee Williams, Adam Sandler, Doc Severinsen, Ed Asner, A.J. McLean, Toni Tennille and Daryl Dragon (a.k.a. The Captain & Tennille), Calvin Coolidge, Truman Capote, and Jack Osbourne. Famous people who don't own bulldogs include Carrot Top and former host of *Solid Gold* Rex Smith. (There must be more, but I thought that these two, above all others, were worth mentioning.)

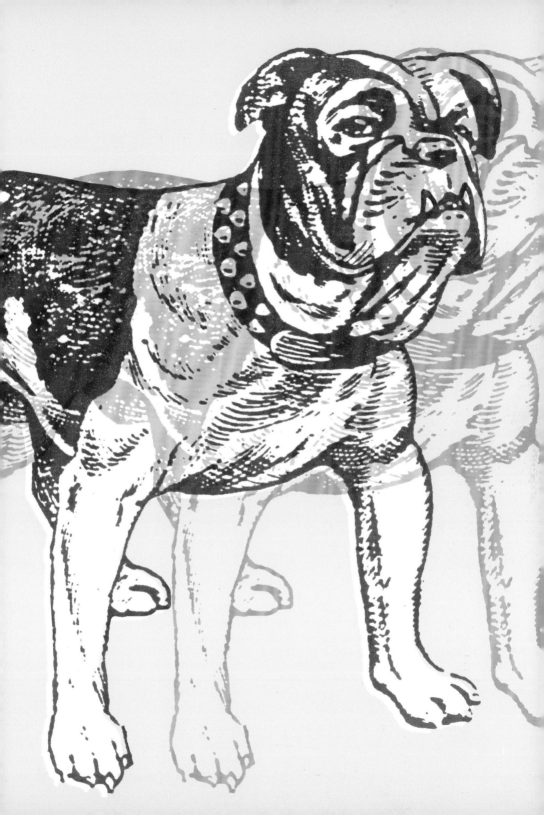

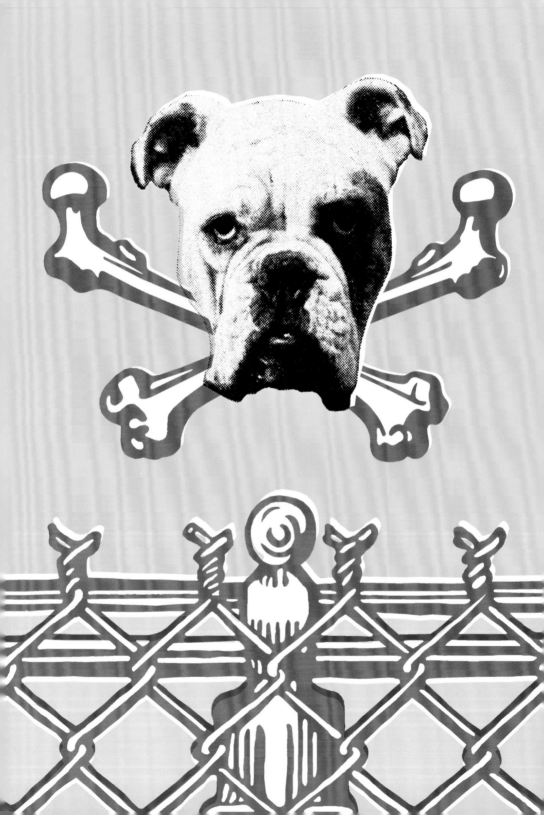

Traditionally, the meanest, most deranged and psychopathic dogs are used to guard junkyards. The reason is simple: We must protect our nation's supply of rusted starters for 1978 AMC Pacers. We cannot allow the rims of an old Ford 9N tractor to fall into the hands of the enemy. But most important, the cracked windshield of a 1988 Dodge K-Car is treasure beyond words and must be guarded. Junkyard dogs are doing important work.

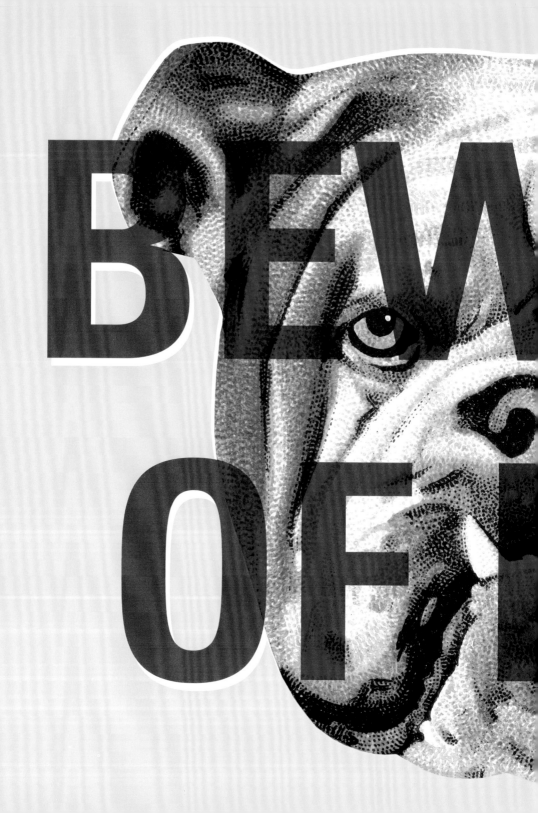

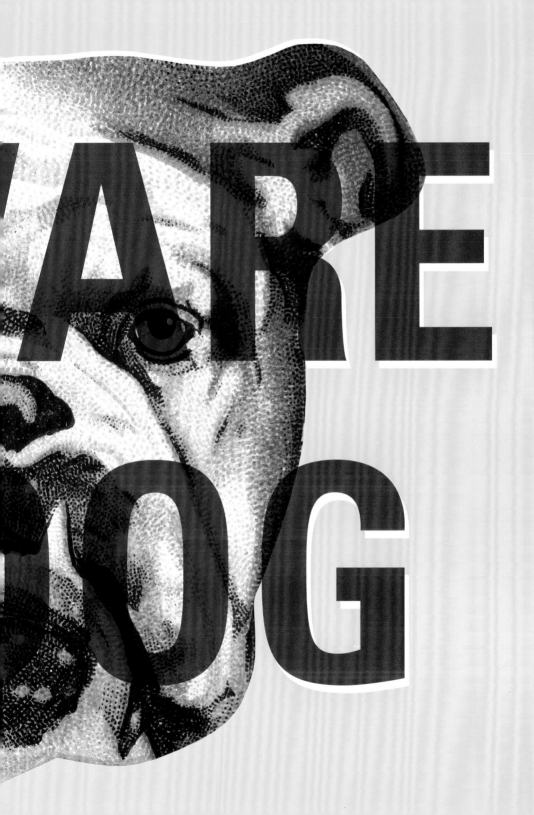

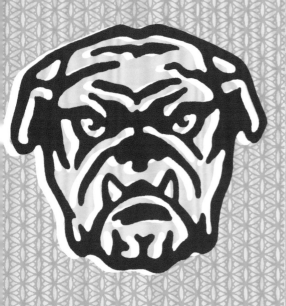

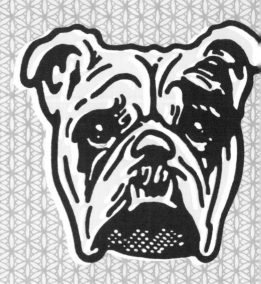

Though one theory holds that all dogs descended from wolves, it seems clear that these guys are the result of crossing a badger with a dust mite. Notice the squat, badger-like

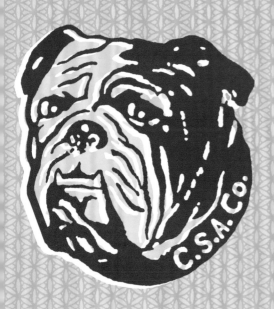

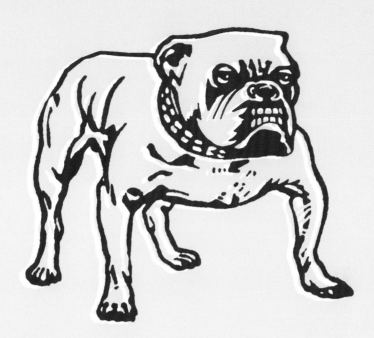

stance; the powerful front claws used for digging up lizards, birds, eggs, and insects; and the prehistoric mouthparts meant for digesting dander and dead skin.

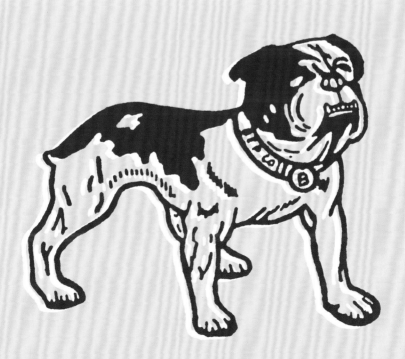

# TICKED OFF

One of the joys of pet ownership is the time spent grooming your animal companion. Nothing can compare to the calming hours devoted to wrenching a brush through the thick tangle of matted fur, bathing your dog in an effort to keep ahead of the buildup of secreted oils and accumulated filth, and tamping down the pungent hound smell. Cherish those moments in spring when the wood ticks are especially active, and dozens have cemented their jaws into the flesh of your dog, sucking greedily at his blood until engorged and swollen to the size of table grapes. Isn't that why you bought a dog in the first place?

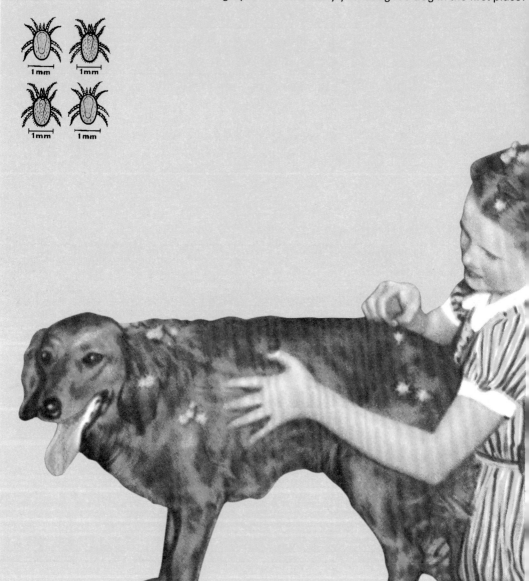

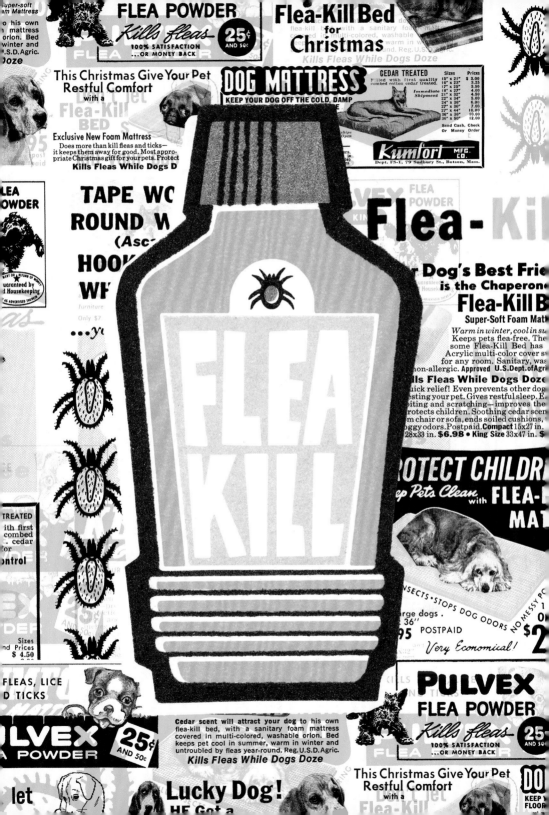

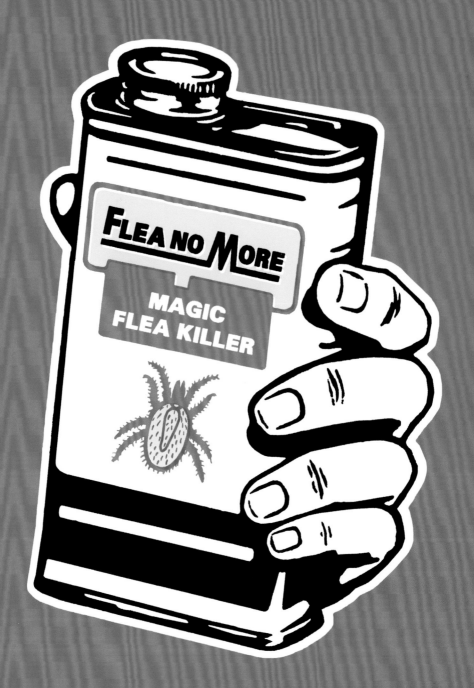

Man had lived in harmony with the flea for countless thousands of millennia—until the moment we domesticated the dog. Once that happened, fleas waged open war, nesting in our homes and giving

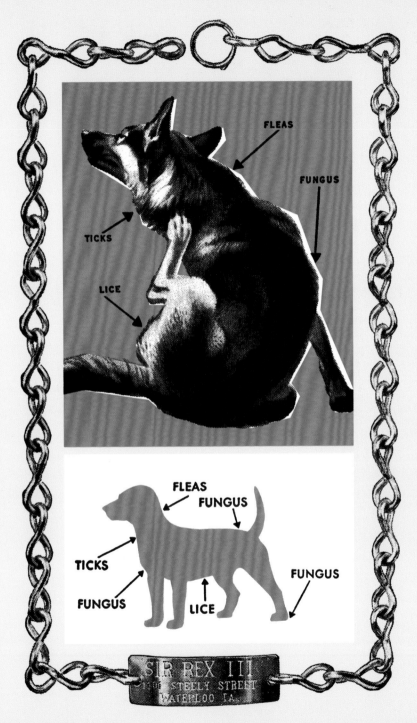

us several annoying plagues. To control them, it's recommended that you apply a strong insecticide monthly, and as a precaution, build a bonfire and burn all sheets, mattresses, clothing, and drapes.

# DIRTY DOG

Dogs, whatever their charms, are not complex organisms. They desire only three things; food, water, and humping anything that moves. If a moving object is not handy, they are more than happy to hump any and all inanimate objects. Though it is troublesome and potentially embarrassing when a pleasant visit by your Aunt Betsy is suddenly and violently disrupted as Freckles fully mounts and attempts to make love to her calf, the dog is merely doing what comes naturally and should not be discouraged, lest you hurt his feelings.

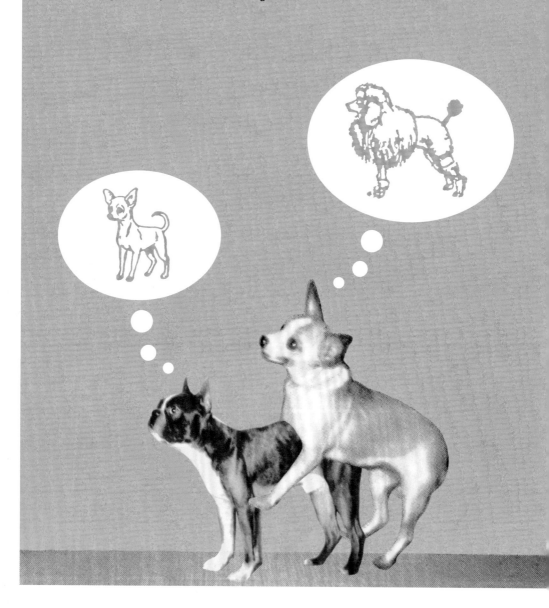

Just like humans, dogs can occasionally have trouble with their bowels and need encouragement and support. That's where King Movement comes in. Show your dog a brief film featuring this

charming, animated spoor extolling the benefits of a good diet for regular and healthy digestive functions, and your pet will be back on track in no time. You've done it again, King Movement!

# DOGGiE-DOO

It's a fact: Carnivores have the foulest droppings in the whole of the animal kingdom. And of the carnivores, dogs have some of the foulest—right behind the skunk, civet, weasel, reef crab, mulberry whelk, mongoose, walrus, and the king of foulness: the common house cat.

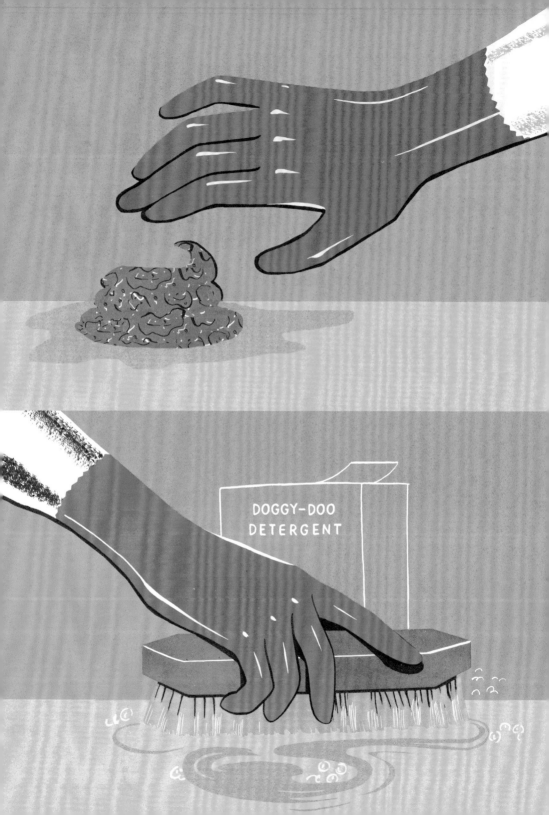

Cleaning up after your pet's accident is easy. Simply wriggle into a CDC-approved biohazard suit, remove the offending filth, launder with a strong detergent, and finish with a generous coat of medical-strength bleach.

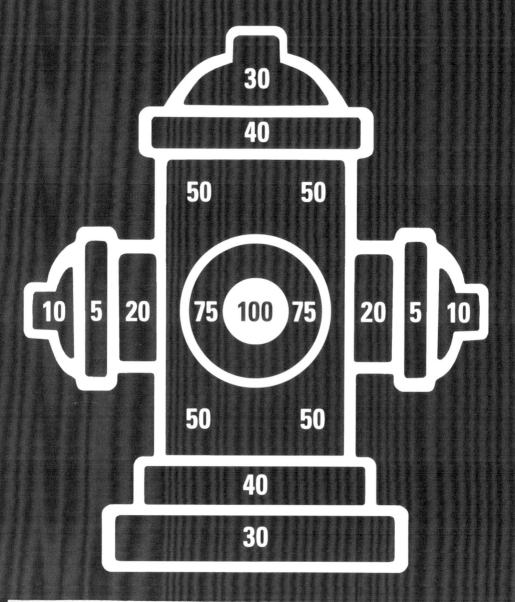

It's an age-old mystery: Why do dogs seem magically compelled to offload hot streams of urine on fire hydrants? As dogs in the wild will mark trees with their urine, one theory holds that dogs think fire hydrants are trees—this despite the fact that fire hydrants are shorter, made of metal as opposed to wood, are of a different color, and lack leaves of any kind. (Remember: dogs = stupid.)

On a good day, a dog can do more than $400,000 worth of damage to your home and possessions. Aside from chewing slippers and teddy bears, dogs have been known to chew up Botticelli paintings, Ming vases, Double Eagle gold coins, and several dozen Guttenberg bibles.

Your pooch simply won't be happy if he can't occasionally whip it out and lay down a patch on your throw rug. This is probably something dogs need to do to vent their anger over being domesticated. Simply buy a pallet of throw rugs and replace the stained ones as needed.

Here we see an artist's depiction of the time Milton Florsheim attempted to explain his idea for the men's dress shoe to his puppy, Mr. Snuggles. After four long hours, the poor dog showed no sign of comprehension, so Florsheim moved on to ladies' casual.

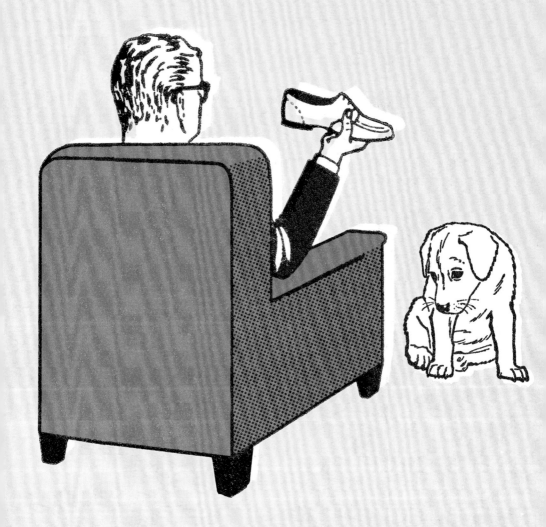

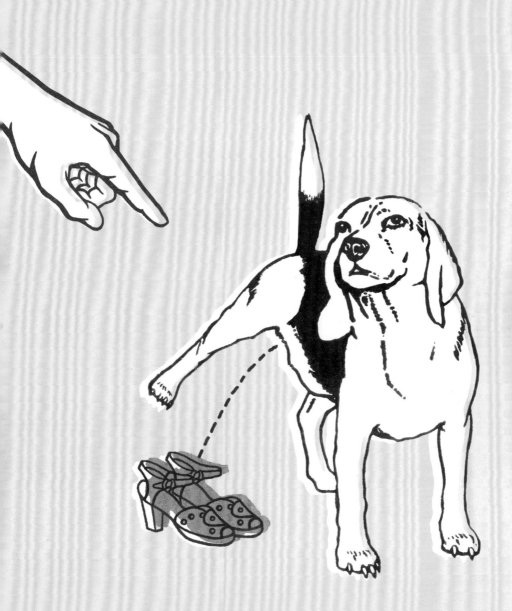

Amazing but true! On the 28th of October, 1977, a beagle named Cookie fully ingested a pair of his master's open-toed Mary Janes. Twelve hours later, with remarkably little discomfort, he passed them. After a light cleaning, they were ready to go, none the worse for wear!

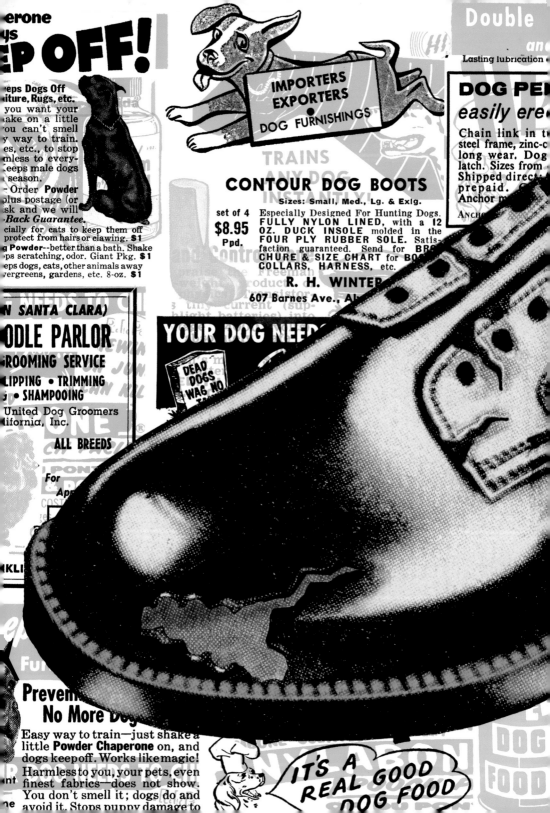

To a dog, every shoe in your closet looks like jerky. But you can take steps to avoid having your favorite bucks torn to shreds. Simply provide your pet with readily available rawhide chew toys and, should he get a hold of your shoe, take it away and gently remonstrate him. For a permanent, if somewhat extreme solution, you could lightly coat all of your shoes with a fast acting poison.

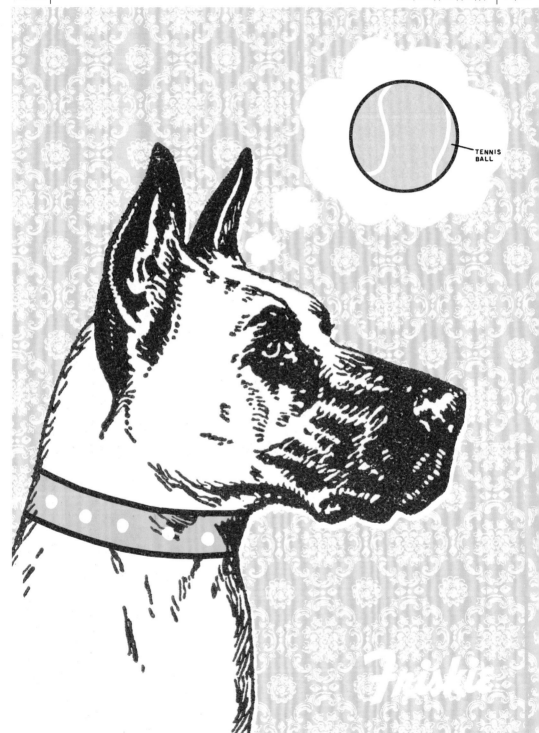

Who can know the mind of a dog? Certainly not a dog. Their ability to self-examine is shockingly limited, and most of the time they while away the hours daydreaming about tennis balls or how nice it would be to eat grass and throw up. This guy, for reasons unknown, spends his time thinking about transparent frogs. Odd, that.

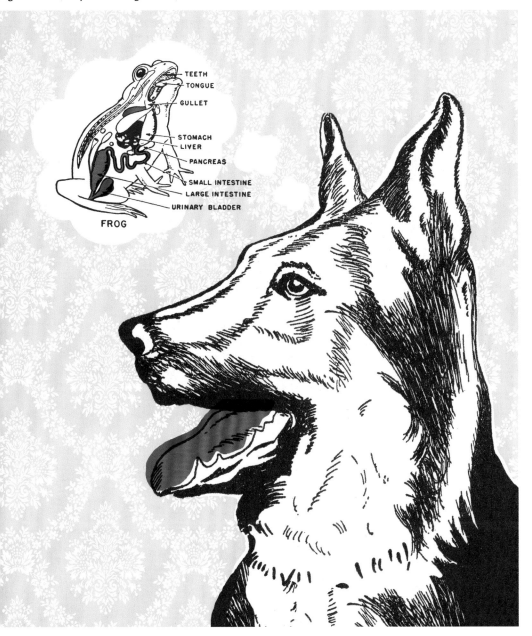

# BISCUIT CASE

To keep his teeth strong and healthy, always provide your dog with a wide variety of chew toys. You might want to try pigs' ears, which are gently sliced off the creature's head and then lovingly smoked over domestic hardwoods. Or one of the many organic chews, made from only the choices cuts of free-range Argentinean cow innards and blended with the finest grades of sand. Or you could simply throw down a whole pork shoulder and let him drag that around the house for a time.

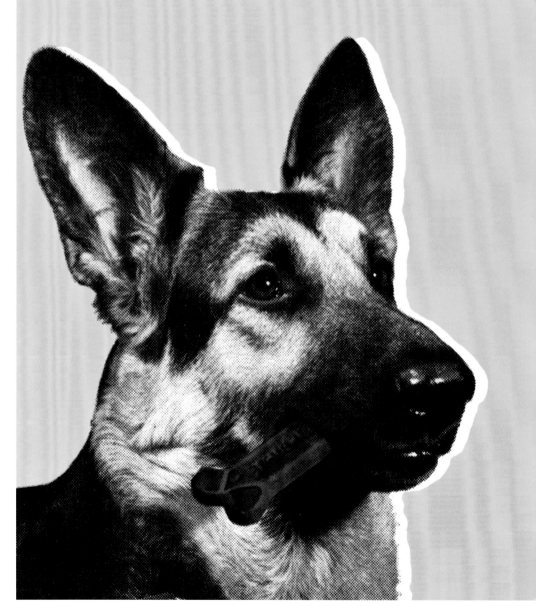

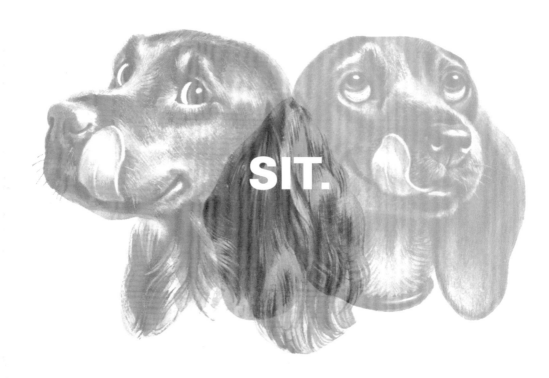

SIT.

Above are Dot and Spot, the Siamese-twin Irish setters. Conjoined at the ears, Dot and Spot moved in a nearly continuous clockwise circle for most of their lives. Training was difficult, because when the command was given to sit, both thought their owner was talking to the other twin.

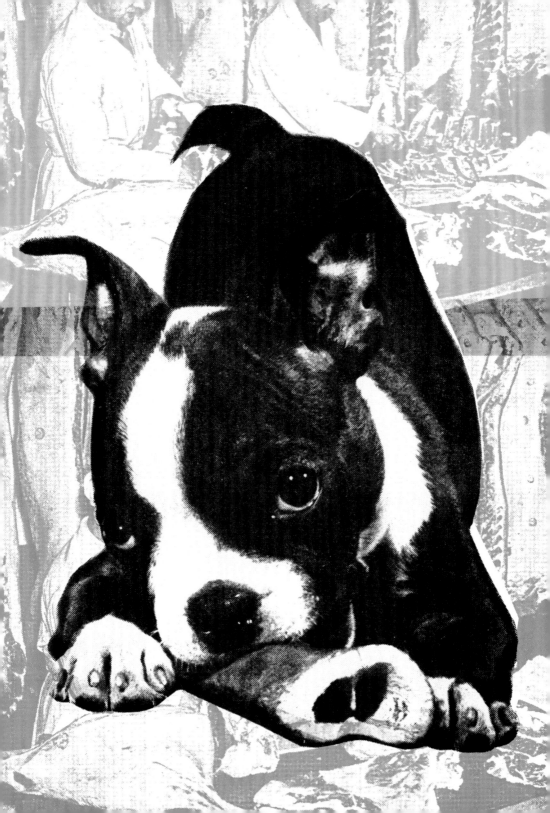

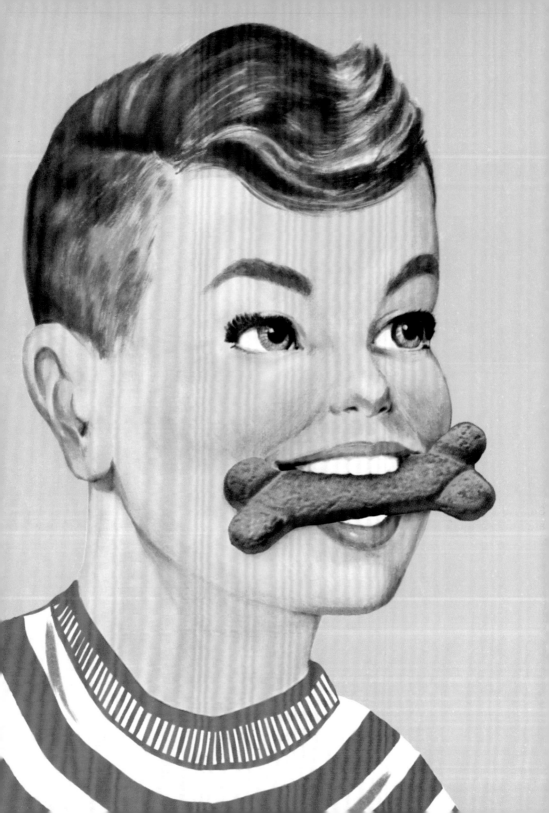

Some doggy treats look good enough to eat, but don't imitate little Grover (opposite). Hours after munching down that "treat," he contracted giardia and was hospitalized for eight weeks.

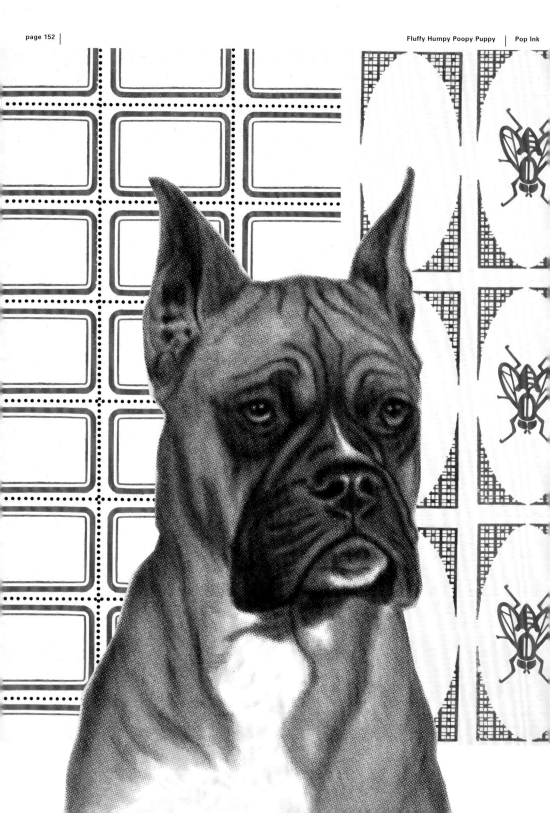

Dogs' stomachs can tolerate food that is up to 78 percent bacteria, so if your refrigerator fails and your food goes bad, don't toss it. Give that fetid roast to Pappy. It's not spoiled to his iron gut.

The pet-food industry is regulated by the federal government, but barely. It's hard to name an ingredient, no matter how vile, that can't be legally added to commercial dog food. Ground glass, perhaps, at least in quantities over 400 parts per million. Below that, you're fine.

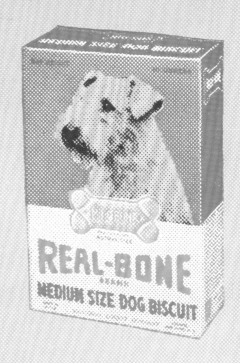

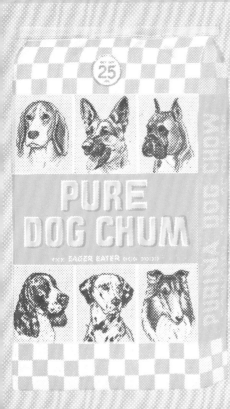

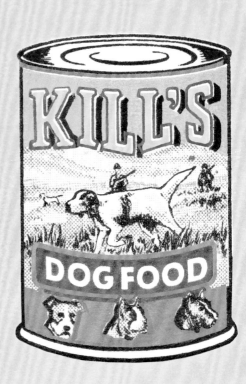

## Ingredients:

Mechanically separated horse, opossum substitute, partially hydrogenated raccoon giblets, reconstituted toenail meal, de-fatted rat hide (some fat added back for consistency), smoke flavoring. May contain one of the following: Grade CC floor sweepings, FD&C dust #10, recycled cow tongue, sealing wax, food-grade tar.

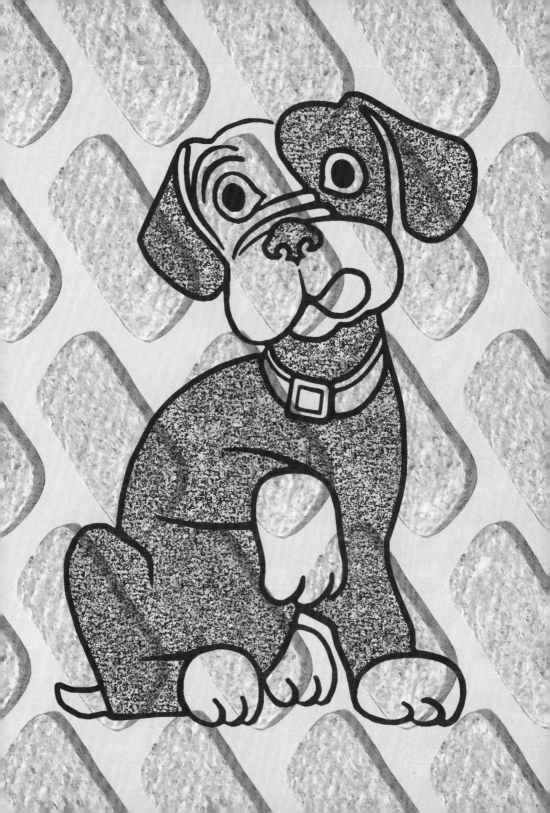

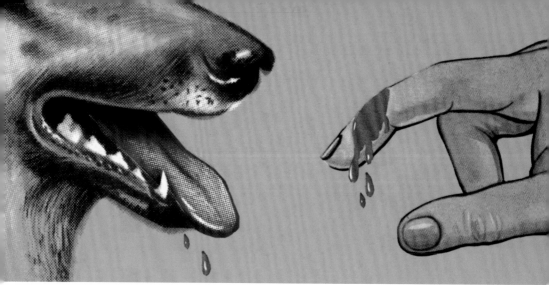

Though they are domesticated, dogs retain their animal instincts. They may nip at you, form into packs, cull you from a herd of other humans because you look weak, drag you down by your hamstrings, and feed on your liver—before their tame nature takes over again.

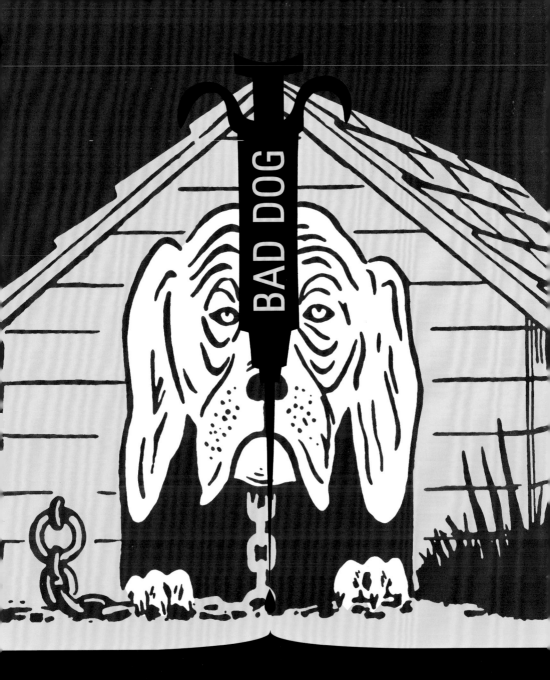

Some dogs nip once and never do it again. Others get a taste for human flesh and, after biting several times, begin to look longingly at the neighbor boy's throat. As sad as it is, they must be destroyed. Not just put down, mind you, but utterly destroyed, with commercial or military explosives, by placing in a blast furnace, or by dissolving in nitric acid. It provides a grim warning to all the other dogs.

# DOG DISH

A taboo in the U.S., dog meat has been a staple in many countries, including China, where it is served as a dish to warm one up in the winter, and Korea, where it can be found in poshintang, a stew that is rumored to increase sexual health. This practice is particularly revolting to Westerners, including French actress Brigitte Bardot, who has campaigned to stop it—right before tucking into a meal of rooster combs in brown butter, paté de fois gras, frogs' legs, and terrine of sweetbreads.

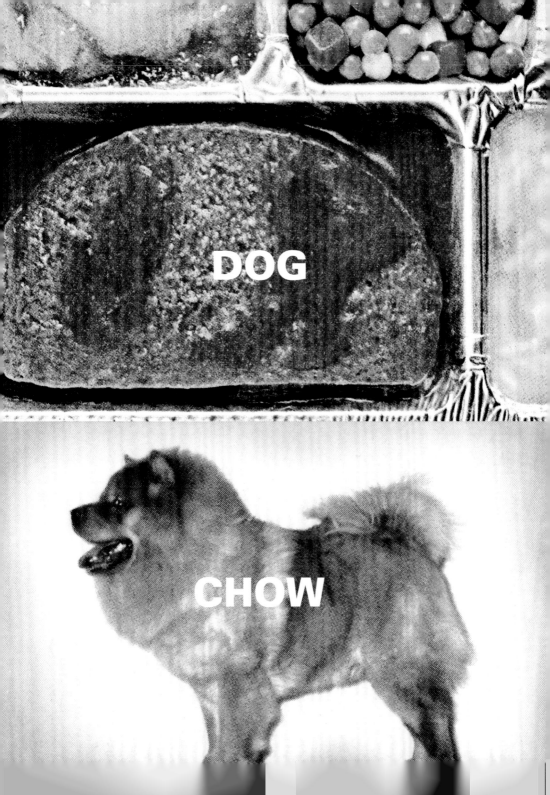

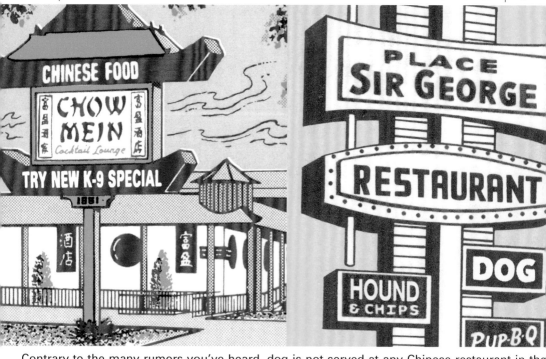

Contrary to the many rumors you've heard, dog is not served at any Chinese restaurant in the U.S.. That pungent, stringy dark meat you taste is, um, chicken. Imported, Chinese chicken.

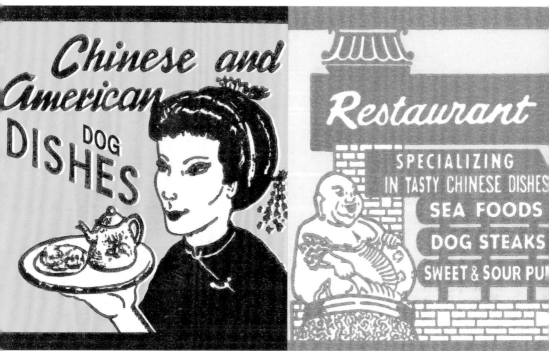

On an intelligence scale, dogs are thirteen times dumber than humans, while pigs are only three times dumber. This means that the only animals smarter than pigs are primates and dolphins.

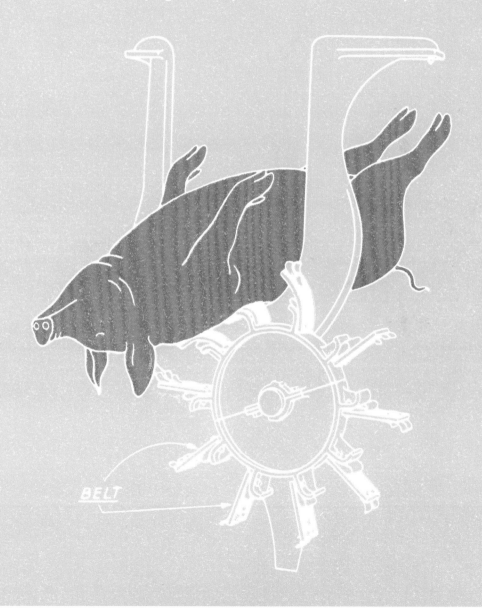

BELT

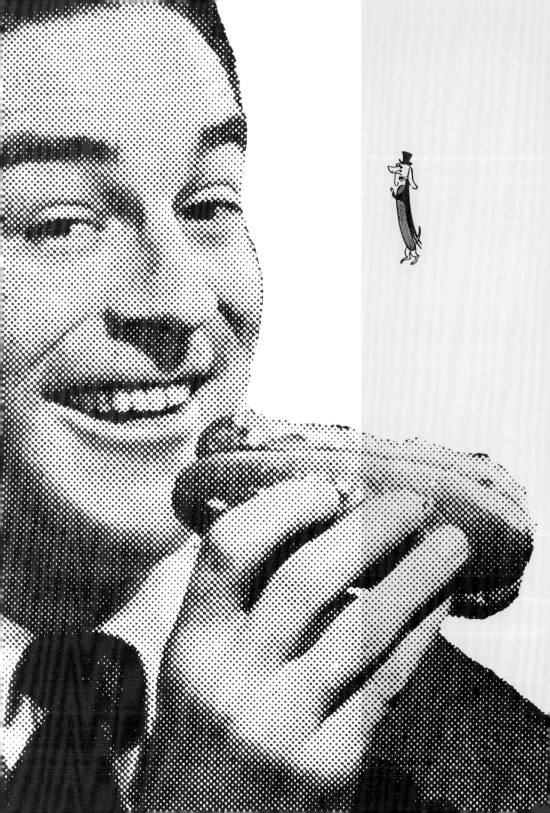

There's no dog meat in hot dogs, so how did the popular wiener get its name? Simple. Up until 1997, due to a loophole in federal law, hot dogs could legally contain up to 87 per cent dog and dog by-product. A bill was passed ending the practice, but the catchy name has stuck with us ever since!

The dachshund is a remarkable breed of dog. Originating in Germany, the dachshund was bred for the purpose of crawling into badger holes, cornering the inhabitants, and barking like crazy. There was no purpose to this practice whatsoever. The Germans just wanted to see if it could be done.

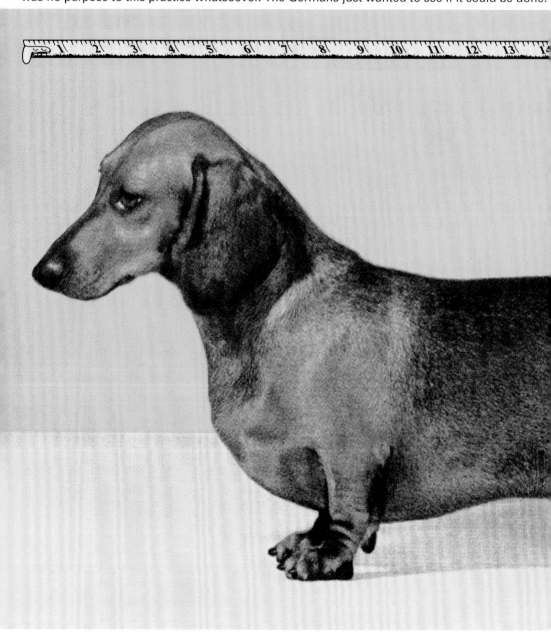

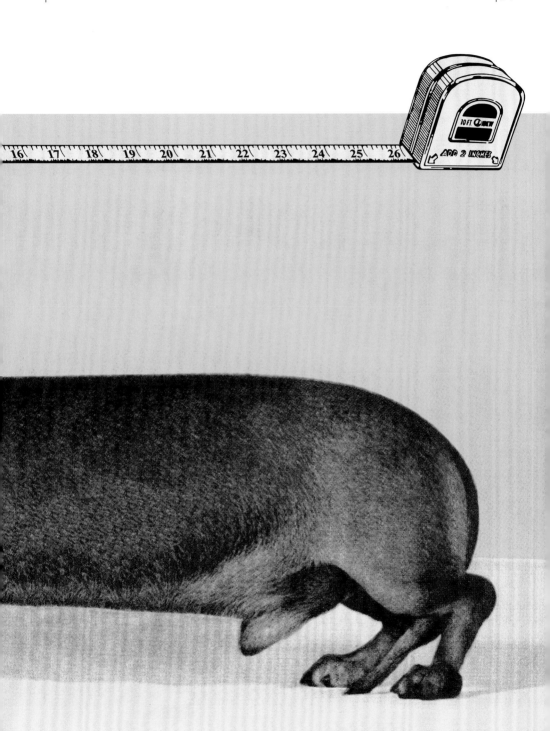

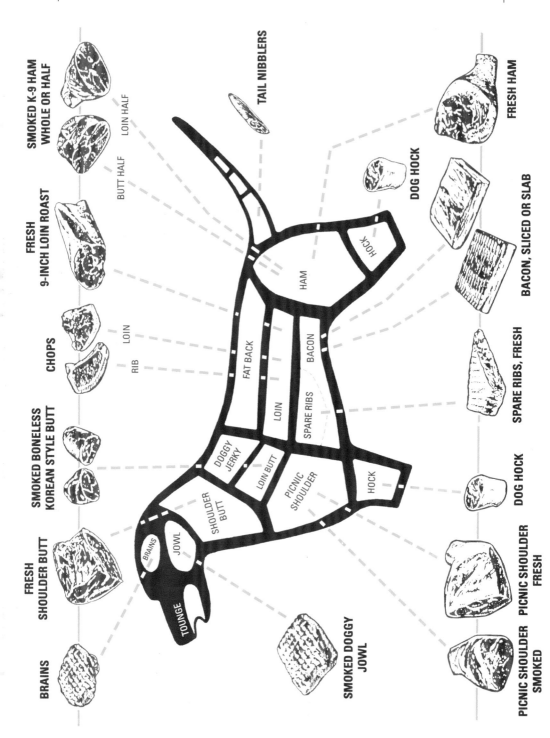

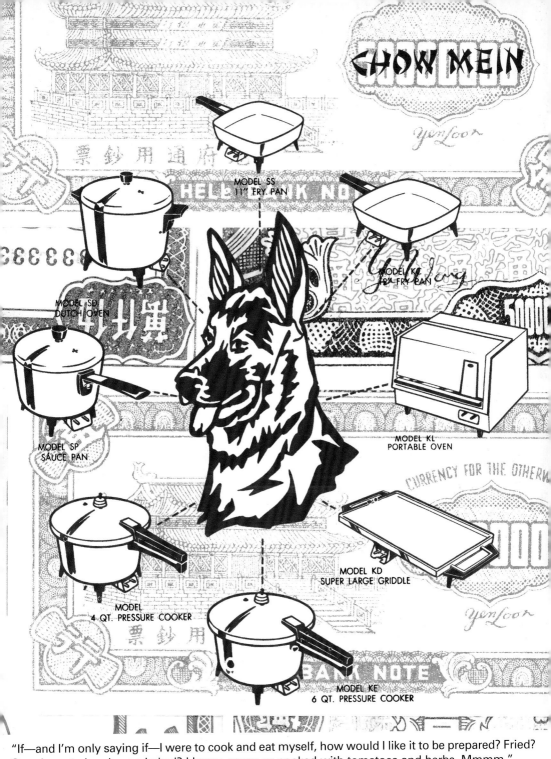

"If—and I'm only saying if—I were to cook and eat myself, how would I like it to be prepared? Fried? Crumb-coated and oven-baked? I know, pressure-cooked with tomatoes and herbs. Mmmm."

# DOG GONE

Dogs are short, out of the sight line of a driver, and not always aware of the their surroundings. You're seventeen, just purchased your first car, and have a low tolerance for alcohol. It's a recipe for disaster. Yes, that sickening thud you heard while cruising past your house to check if your parents' light was still on was, in fact, Bubby, the beloved family dog. There's no way around it. You can't walk away from this one. You have to take responsibility, understand? Do it by hosing off your grill, dragging Bubby into the woods, burying him with leaves, and pretending you have no idea where he went.

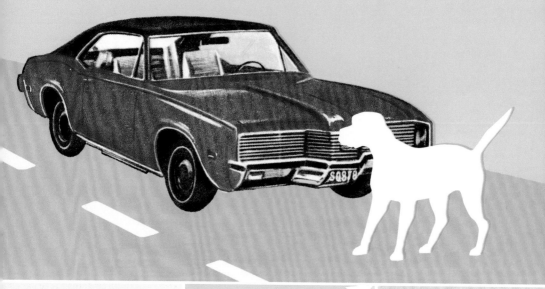

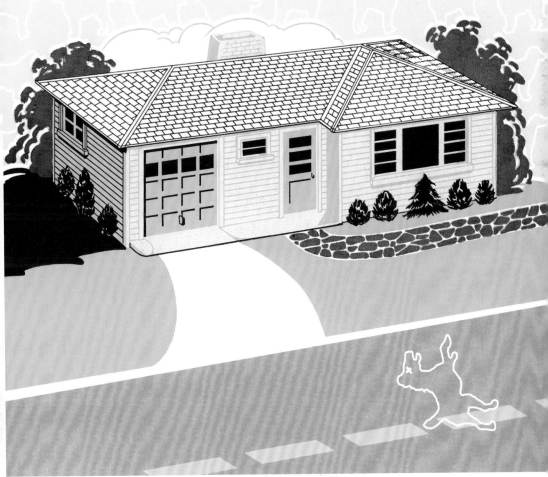

# DOGGIE HEAVEN

Dogs can't live forever. Be comforted by the fact that your treasured pet is spending eternity in doggy heaven. Unless he was bad. Then he's burning in hell for all eternity.

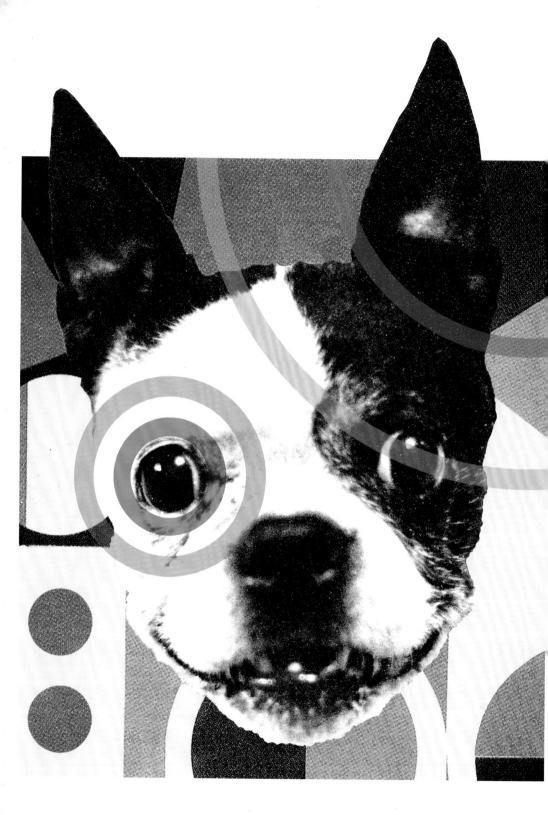

This book is dedicated to Pignewt. I grew up in Boone, a small, remote farm town near the center of Iowa. When I was seven years old, my dad brought home a small dog. She was a strange-looking creature and seemed completely oblivious to how homely she was. My mom used to say, "She's so ugly, she's cute!" Dad told us she was a Boston terrier. I remember thinking this must be what all the dogs in Boston look like. We named her Frisky, but her nickname was Pignewt. She had a flat face. Half of it was white and half was black, topped off by two pointy ears that stood perpetually at attention. The only relief on her perfectly flat face was a pair of buggy-out eyes. She resembled the giant African vampire bats we looked up in our *Encyclopedia Britannica* set. Pignewt didn't realize she was a dog. Rather, she considered herself the fourth Anderson sibling. She had free reign over the town of Boone and roamed wherever she pleased. She was an affable pup, and nearly everyone in town knew her by name. She spent most of her time with me and my brothers, exploring the park and the woods beyond. One blistering day in July, when I was nine years old, I took a shortcut through the park on my way home from the Dairy Queen. I could see our house just beyond the wall of hedges that marked the park's border. As I stepped into the shadow of a towering 100-foot oak tree, I heard a chattering sound coming from the branches far above. My eyes, adjusting to the shadow, finally made out the shape of a large gray squirrel. He was extremely agitated and was squealing and chattering with erratic, convulsing movements. I yelled back, "Shut up you crazy squirrel." Looking down, he let out a sick squeal and leaped kamikaze-style out of the tree, directly at me. Unfortunately (for him), he wasn't a flying squirrel. He ended his ten-story leap with a disturbing splat on the hot asphalt road about twenty feet short of me. I thought for sure the flattened varmint was now done for. Picking up a broken tree branch, I walked forward to inspect the rodent's lifeless carcass. I poked it with the stick—not even a twitch. I bent closer and poked it again. With a shrill, deafening squeal, the squirrel sprang to life, its yellow rat-like teeth gnashing at the air as it lunged for my face. In that split-second glimpse, I saw its blood-red eyes filled with an insatiable evil, bred of pure insanity. White foam sprayed out of its mouth like a can of Ready Whip with a broken nozzle. I realized that this was no ordinary squirrel but a deadly, venomous, rabid squirrel! I blocked the creature's leap with the branch, and in the same gesture turned and ran for the wall of hedges. Glancing backward, I saw that the squirrel was after me . . . and gaining! Panicky fear gripped me as I sprinted for the hedge. With a surge of strength, fueled by a flood of terror-induced adrenaline, I leaped to hurdle the green leafy wall. At that instant, the rabid squirrel also sprang, flying through the air and landing on my shoulder. Time shifted into slow motion. I could smell the squirrel's putrid, hot breath on my neck and feel the spray of foam and blood from his wretched, diseased mouth. I knew those infectious, gnawing yellow fangs were just inches from my pounding jugular vein. At that moment I knew I would die, and not a good or heroic death, but a horribly painful and embarrassing death-by-squirrel. Just then, my peripheral vision detected a blaze of black and white flying through the green hedge. It was Pignewt! She ripped the squirrel off my neck in midair and landed hard on the ground. Suddenly the squirrel was on top of her, with a ferocity spawned by disease. The rabid vermin bit a bloody chunk out of Pignewt's neck. This action triggered thousands of years of repressed bulldog killer instinct. Pignewt surged forward, jaws chomping down with an audible crunch and locking on the squirrel's puny neck. A dozen violent shakes of the dog's massive bulldog neck ensured the multiple snapping of the squirrel's scrawny spine. Not content to simply kill the filthy, bushy-tailed rat, Pignewt then started to chow down on the squirrel guts, pulling out its stringy innards and eating them. "Yes!" I yelled. "Good dog! Eat that sick rodent. Rip its guts out!" Minutes later my mom was rushing me, Pignewt, and the dead squirrel (in a ziplock bag) to the veterinarian. The fact that Pignewt was bleeding profusely did not dampen her buoyant spirits. After all, she had just fulfilled her destiny by not only protecting me but also tearing apart the nasty little beast foolish enough to think he could take a bite out of her and live to tell the tale. Dr. Sandberg was a distinguished, silver-haired, serious-minded veterinarian. He gave Pignewt twelve stitches and then examined the dead squirrel. "Yes," he said, "that confirms it. In my forty-three years of practice, I have never seen a squirrel quite this rabid." Then he turned to me, placed his hand on my shoulder, and said, "Son, this dog may very well have saved your life!" I could hear trumpets blowing and angels singing as the clouds of squirrel heaven parted, forming a backdrop for a victorious Pignewt sitting on a golden throne made of dried, rabid squirrel carcasses. Because Pignewt had already been vaccinated for rabies, she suffered no ill effects. She wore her neck bandage proudly, and her heroic status grew daily as the rabid squirrel story spread like a grass fire throughout the small town. According to my friends, she had achieved a place of fame and stature shared only by the likes of Lassie, Rin Tin Tin, and Benji.—Charles S. Anderson

**Charles Spencer Anderson is a designer and pop-culture junkie.**

Pop Ink is the result of over fifteen years' worth of work by the Charles S. Anderson Design Company (est. 1989), and a lifetime's work by its founder. Fighting to humanize slick, impersonal corporate design, Anderson popularized the use of hand-drawn art, uncoated paper, and irreverent humor through work for long-time client and friend Jerry French of the French Paper Company. Charles S. Anderson Design Company's approach to design is a continuous evolution inspired by the highs and lows of art and popular culture. CSA Design has worked with companies as diverse as Barneys, Urban Outfitters, Coca-Cola, Target, Best Buy, Turner Classic Movies, Nike, Blue Q, Levi's, Ralph Lauren, and Paramount Pictures. The firm's innovative identity, product, and package design has won nearly every industry award possible. Anderson has three sons, Matt, Blake, and Sam, and lives in Minneapolis with his wife, designer Laurie DeMartino, and their daughter, Grace Annabella.

Charles S. Anderson Design Company's work has been influential in the industry both nationally and internationally and has been exhibited in museums worldwide including: The Museum of Modern Art, New York; The Nouveau Salon des Cent-Centre Pompidou, Paris; The Smithsonian Institution's Cooper-Hewitt National Design Museum, New York; and The Institute of Contemporary Arts, London.

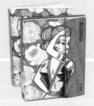

Karen Heineck

Erik Johnson

Jovaney Hollingsworth

Sheraton Green

Other books in the Pop.Ink Collection. Start your library today!

Each member of the CSA team brings an individual aesthetic that continues to evolve our design approach.

124 North First Street Minneapolis MN, 55401

Built in 1884, this renovated historic building, located in Minneapolis's warehouse district, is home of the Charles S. Anderson Design Company.

Also available: Note Cards and Journals—collect them all!

**Writer / Actor Michael J. Nelson** served as head writer for ten seasons and on-air host for five seasons for the legendary television series *Mystery Science Theater 3000*. He is the author of *Happy Kitty Bunny Pony*, *Goth-Icky*, *Love Sick*, *Mike Nelson's Movie Megacheese*, *Mind Over Matters*, and the novel *Death Rat*.

**VISIT THESE SITES:**     **WWW.POPINK.COM**     **WWW.CSADESIGN.COM**     **WWW.CSAIMAGES.COM**

Published in 2006 by Abrams Image, an imprint of Harry N. Abrams, Inc. All rights reserved. No portion of this book may be reproduced, stored in a retrieval system, or transmitted in any form or by any means, mechanical, electronic, photocopying, recording, or otherwise, without written permission from the publisher.

Design by Charles S. Anderson Design Company
CSA Design, 124 North First Street, Minneapolis, Minnesota 55401
www.csadesign.com

Images by Pop Ink
www.popink.com

Pop Ink is a copyrighted collection. Images in this book may not be reproduced, scanned, stored, or altered without the prior written consent of CSA Design.

**HNA** ▮▮▮▮▮
harry n. abrams, inc.
a subsidiary of La Martinière Groupe
115 West 18th Street
New York, NY 10011
www.hnabooks.com

K Y M C K Y M C K Y M C K Y M

Library of Congress Cataloging-in-Publication Data has been applied for.
ISBN 0-8109-7057-0

Printed in China
10 9 8 7 6 5 4 3 2 1